★ MONTGOMERY'S ★

CIVIL HERITAGE TRAIL

A HISTORY & GUIDE

SITE DIRECTORS AND FRIENDS OF THE CIVIL HERITAGE TRAIL

FOREWORD BY MORRIS DEES

THE
History
PRESS

Published by The History Press
Charleston, SC
www.historypress.net

Front cover, middle right: Courtesy of the Alabama Department of Archives and History.
Back cover, inset: Courtesy of the Montgomery Convention and Visitors Bureau.

First published 2017

Manufactured in the United States

ISBN 9781467135474

Library of Congress Control Number: 2016953088

CONTENTS

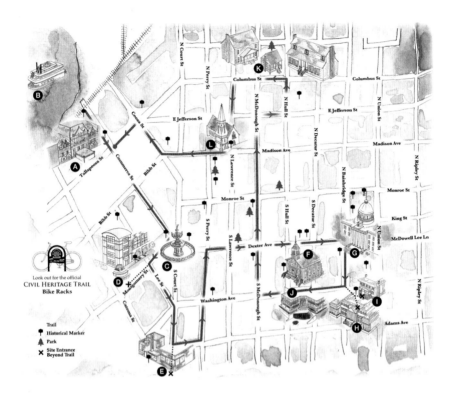

The Civil Heritage Trail Map leads visitors to the twelve sites in downtown Montgomery that were significant to the Civil War and the civil rights movement. *Downtown Business Association.*

A: Union Station
B: Riverfront Park and *Harriott II* Riverboat
C: Court Square and Fountain
D: Rosa L. Parks Library, Museum and Children's Wing
E: Freedom Rides Museum at the Greyhound Bus Station
F: Dexter Avenue King Memorial Baptist Church
G: Alabama State Capitol
H: Alabama Department of Archives and History and Museum of Alabama
I: First White House of the Confederacy
J: Civil Rights Memorial and Center
K: Old Alabama Town
L: St. John's Episcopal Church

MONTGOMERY AND THE CIVIL RIGHTS MOVEMENT

In 1987, I led the Southern Poverty Law Center's successful legal battle against the United Klans of America after its leaders conspired to kill a black teenager in Mobile, Alabama, six years earlier.

The murder of Michael Donald, who was chosen at random, echoed the darkest chapters of our nation's history—a time when hooded nightriders terrorized the African American community for daring to challenge Jim Crow.

The United Klans was responsible for some of the bloodiest violence and terrorism of the civil rights movement. In 1961, its members attacked the Freedom Riders. In 1963, they bombed Birmingham's Sixteenth Street Baptist Church, killing four little girls. In 1965, they murdered Viola Liuzzo, a wife and mother from Detroit who was ferrying activists home after the Selma–Montgomery voting rights march.

Decades later, the group was still active, still stoking hate and committing racial violence.

Thankfully, we won a $7 million verdict that put the group out of business once and for all. The all-white jury's decision signified the monumental transformation of the Deep South. And it was a measure of justice for a horrific hate crime that seemed unthinkable to many people years after the end of the civil rights movement.

At the time, I realized that so many people had already begun to forget the hard-fought battles and the sacrifices of those who risked their lives in the movement. Many young people didn't know much of anything about the struggle and didn't know the names of those who died for equality.

That's why we commissioned Maya Lin to design the Civil Rights Memorial. Today, the memorial attracts tens of thousands of schoolchildren and others each year. I'm deeply gratified that it's part of the Civil Heritage Trail and among the important sites featured in this book.

The memorial and its interpretative center tell the stories of the men, women and children killed during the movement and of the other pivotal events that propelled the country forward. Understanding this history helps us make sense of the present. Preserving it prevents us from taking our progress for granted and inspires us to continue working for equality in our daily lives.

Other sites on the trail are equally inspiring and informative.

Just below my office window, for example, stands the Dexter Avenue King Memorial Baptist Church, the church where Dr. Martin Luther King Jr. gained international fame as he rose to become the movement's leader in the 1950s. Down the street from there, at Court Square, visitors can see where Rosa Parks boarded a bus on December 1, 1955, and refused to give up her seat to a white man, sparking the Montgomery Bus Boycott that catalyzed the movement. Nearby is the Rosa Parks Library and Museum, built on the spot where she was taken off the bus and arrested for her act of civil disobedience. There's also the bus station where the Freedom Riders were beaten and the Alabama capitol, where the Selma march concluded with King's searing denunciation of segregation in 1965.

The Civil Heritage Trail helps ensure that the memory of the strength and commitment of the movement's foot soldiers, the battles fought with nonviolent resistance and the lives lost won't fade with each new generation.

Collectively, these sites serve as a powerful testament to the sacrifices made for a better tomorrow. They remind us that we must stand up and speak out to ensure that our country lives up to its highest ideals. And they inspire us to continue the march for justice, regardless of the cost.

MORRIS DEES

MONTGOMERY AND THE AMERICAN CIVIL WAR

The importance the Civil War had on Montgomery, Alabama, is still felt in many ways today and serves to beckon tourists from all over the world to the city. Honorary Regent for Life of the White House Association of Alabama Cameron Napier explains:

> People are fascinated with the Civil War that tore our country apart for four long years and which caused such an incredible amount of bloodshed and sacrifice. What better place to experience the places of the past than Montgomery, Alabama—the birthplace of the Confederacy and the Civil War? When tourists visit, they feel they are stepping back into the past and it is an almost surreal moment for many—especially those who have studied about the Civil War and the Confederacy. Visitors come to Montgomery because of its connection to the Civil War and to the civil rights movement to more completely understand in person the sacrifices made by those involved.

After South Carolina, Mississippi, Florida, Alabama, Georgia, Louisiana and Texas seceded from the Union, representatives of those states met in Alabama's state capitol building and formed the Confederate States of America. The Provisional Confederate Congress drafted a constitution in what we call today the "Old Senate Chamber." Its members also elected Jefferson Davis of Mississippi the provisional president of the Confederacy. At the Alabama capitol today, visitors can see the Senate Chamber, restored

to its 1851 décor, as well as the star on the front portico where Jefferson Davis took his oath of office. On the third floor of the Alabama capitol is the Alabama Supreme Court room in which President Davis's body lay in state; his remains were moved from New Orleans to be interred in Richmond, Virginia's Hollywood Cemetery two years after his death. A statue of Jefferson Davis stands tall on the left side of the capitol steps leading up to the front door of the capitol. On the north side of the capitol grounds is the eighty-eight-foot-tall Alabama Confederate Monument. Jefferson Davis laid the cornerstone for the monument at its dedication ceremony in 1886.

Across the street from the south side of the Alabama State Capitol stands the First White House of the Confederacy, where Jefferson Davis and his wife made their home in the spring of 1861 before the Confederate capital moved to Richmond, Virginia. The White House features many personal items of President and Mrs. Davis as well as furnishings of the period. Next door to the First White House of the Confederacy is the Alabama Department of Archives and History, which has a display on Civil War weapons and flags. Also downtown, the Winter Building in Court Square on Dexter Avenue is noted as a Civil War landmark. The telegraph office on its second floor is where the telegram was sent by the Confederate War Department to General P.G.T. Beauregard on April 11, 1861, to "demand evacuation of Fort Sumter or reduce it." Facing Madison Avenue, a bit farther away, historic St. John's Episcopal Church contains the Davis family's original pew, where President Davis and his family worshipped while in Montgomery.

We remember these places and the events that marked them because our country was changed by those events. We do ourselves a great disservice if we ignore history; it is there for us to embrace, the good and the bad. We honor it, and we learn from it. We fought a horrendous Civil War and yet came back together as one nation again, stronger than before. We learn from the past. Lessons from the past make us stronger as we look toward the future.

ANNE TIDMORE

ACKNOWLEDGEMENTS

This book, *Montgomery's Civil Heritage Trail*, is sponsored by the Downtown Business Association. Jeff Andrews, as chairman of the Civil Heritage Trail, has spearheaded the project with committee members Electra Henry, Georgia Ann Hudson and Carole King, who also was a great help with editing. We thank the current president of Downtown Business Association, Clay McInnis, for his support. We are grateful to Karren Pell for editing and organizing the manuscript. We appreciate those who contributed photographs, especially the Alabama Department of Archives and History and Landmarks Foundation.

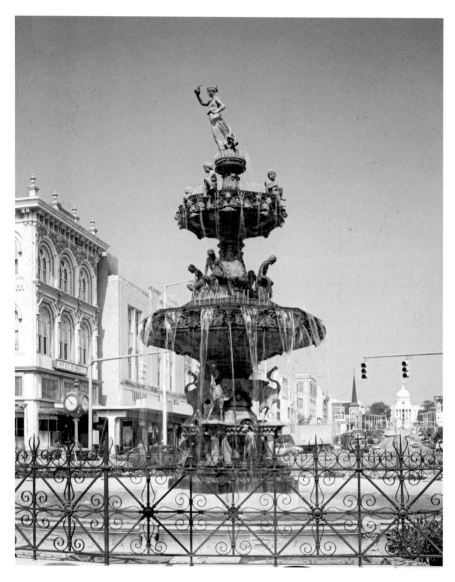

Hebe, cupbearer to the gods, reigns supreme at the top of the fountain in Court Square. The Alabama capitol is visible in the background and the Central Bank–Klein Building stands to the left. *Alabama Department of Archives and History.*

INTRODUCTION

On an unassuming street corner in Montgomery, Alabama, two seminal figures in American history took steps that changed their times and the times to come. Perhaps it is fortunate that Jefferson Davis and Rosa Parks were separated in time by nearly one hundred years, as each was so consumed by purpose that the two would surely have collided violently in the middle of Court Square. They missed one another in time, but the collisions of their work have reshaped their country.

On the afternoon of April 11, 1861, Confederate president Jefferson Davis had just left a meeting with his cabinet at the Exchange Hotel. He crossed east to the only telegraph office in Montgomery with a dire purpose: something had to be done about the Federal troops stationed at Fort Sumter, and Davis meant to do it. The telegraph office had been a beehive of activity ever since the end of January, when a directive from Washington to the New Orleans customs office had been intercepted by a local telegraph operator: "If any one attempts to haul down the American flag, shoot him on the spot."[1] As far as the Confederates were concerned, that January telegraph had been a declaration of war. They ratified a provisional constitution five days later and then spent February and March deciding the fate of Fort Sumter. When they learned Lincoln would provide the fort with additional provisions in mid-April, Davis decided to outmaneuver Washington. He soon reached the telegraph office and sent the message ordering Confederate troops to bomb the Union army and force it to leave Fort Sumter. The first sound of the Civil

War, then, was not the boom of a cannon in Charleston but rather the clack of a telegraph in Montgomery.

Rosa Parks sent no telegram, but her actions on December 1, 1955, delivered a message that would prove every bit as significant as Davis's. She left work that evening and headed west across Court Square to catch the city bus home. A municipal law from 1900 said she would have to give up her seat if more whites boarded the bus, and she knew from personal experience that driver James F. Blake would enforce it—he had already threatened her a few years before. But that night, when a white passenger demanded her seat, Parks had decided she would not move. Blake hollered from the front, but she ignored him. He cut off the engine and walked back to her seat. Parks recounted later: "When he saw me still sitting, he asked if I was going to stand up, and I said, 'No, I'm not.' And he said, 'Well, if you don't stand up, I'm going to have to call the police and have you arrested.' I said, 'You may do that.'"[2]

She spent that night in jail, but her defiance became the catalyst for Martin Luther King's successful boycott of city buses by African Americans. Five years later, and based largely on this event, the U.S. Supreme Court found segregation of public accommodations to be unconstitutional. Like the Civil War before it, the civil rights movement had begun with a strong message on Court Square in Montgomery, Alabama.

That two such singular and distinct events in American history occurred within the same city square is thought provoking. That so few people know this fact is unsettling. Along the streets of Montgomery are sites where the history of the United States was irrevocably altered, yet people pass them daily with no awareness of their significance. The Civil Heritage Trail was conceived as a means for shedding light on the critical role played by the city of Montgomery in American history. The idea came to me on a school field trip to Boston my junior year of high school, and I have been advocating for it ever since.

Of course, I did not expect to find inspiration on that trip. We were traveling to participate in Harvard's Model United Nations, and this native Alabamian was more interested in the forecasted snowfall than in any intricacies of American history. But when our trip sponsor and AP U.S. history teacher insisted we walk the Freedom Trail, I became instantly and utterly captivated.

Arguably the most significant historical attraction in Boston, the Freedom Trail is a two-and-a-half-mile-long route connecting sixteen sites along the streets of the city and across nearly four hundred years of American

history. A tourist can pick up the route within the manicured gardens of Boston Common, walk past the Old State House and Faneuil Hall, visit Paul Revere's silversmith shop and the Old North "Two-if-by-Sea" Church and then end the journey on the other side of Boston Harbor with the USS *Constitution* and the monument to the Battle of Bunker Hill. For a relatively young nation like the United States, such sites make up our history, and I was enthralled to experience it by walking the Freedom Trail.

While the sites are old, the Freedom Trail itself is relatively young. When I researched later, I learned that it was conceived as a specific solution to a tangible threat once facing Boston: urban blight. In 1951, a travel writer for the *Boston Herald* named Bill Schofield lamented the fact that in downtown Boston, similar to other cities nationwide, people and money were fleeing in favor of those shiny, new postwar suburbs accessible to anyone with a car and a down payment. Back in the cities, centuries-old buildings were demolished, and parking lots were paved over the remains. In Boston, Faneuil Hall, now often called the "cradle of liberty" because figures like Revere and John Adams met in the upper room to plan the Revolution, was narrowly saved from demolition. Other sites, however, did not survive. The Boston Latin School—where Sam Adams, Benjamin Franklin and John Hancock all studied—is today marked by only a plaque on the Freedom Trail.

Schofield, as a travel writer, understood a relevant point about people and history: we crave a connection to our past, and we believe that *places* can mediate that connection to us today. People will travel the world to walk in the footsteps of great men and women. Humans have an almost primal desire to experience for themselves the history that continues to shape their lives; if the best link to that history is a place, then people will invariably visit that place.

With this fact in mind, Schofield argued that Boston should link its remaining sites of historic significance into a unified attraction. He suggested painting a line down the center of the sidewalk to guide tourists from one location to the next. Sites that naturally drew many visitors, such as the Massachusetts State House or the site of the Boston Massacre, could lead visitors to burial grounds and historic markers that, though located between the important sites, tended to be neglected. Everyone would benefit, and the plan would cost only as much as a bucket of paint.

During this time, Boston mayor John Hynes had a problem: Boston—birthplace of the American Revolution—was a city teetering on collapse. He needed a solution fast. Hynes established the Boston Redevelopment Authority to spur downtown investment. Though endowed with resources,

the organization could not artificially generate the demand needed to justify redevelopment. Then Hynes learned about Schofield's Freedom Trail and became its leading champion. Where Schofield had seen the path between sites as a way-finding convenience for tourists, Hynes understood something he could literally take to the bank: a walking tour would generate desperately needed foot traffic in commercial districts then marred by broken glass and boarded-up storefronts. By directing investment activity to corridors drawn between sites with inherent appeal, Boston would create a sliver of redevelopment that would then ripple outward in all directions, ultimately benefiting the entire city. Hynes made the trail official within sixty days of reading Schofield's editorial.

The Freedom Trail was an instant success. The union of historic sites became so highly regarded by 1974 that the National Park Service granted it federal recognition as the Boston National Historic Park. This year, more than four million people will walk the Freedom Trail. Many will stay in vibrant downtown Boston while attending conferences at the gleaming Hynes Convention Center. Clearly, the line connecting Boston redevelopment success to the Freedom Trail is as direct and unmistakable as the line of red bricks connecting the historic sites of Boston.

So when I returned home, I could not stop thinking about the Freedom Trail. I knew intimately the history of Montgomery and its connection to both the Civil War and the civil rights movement—a relationship parallel in many ways to the connection between Boston and the American Revolution—and so I decided: Montgomery needed a Freedom Trail of its own. Our stories needed to be told in this powerful, interactive way.

I first proposed the idea in an editorial for the *Montgomery Advertiser*. City councilman Tracy Larkin was interested, as was Mayor Bobby Bright. But in 2002, I headed off to college without leaving behind sufficient momentum for the trail to come to life, and so it withered on the vine. Nothing more occurred until I returned from graduate school, when the Montgomery Chamber of Commerce asked that I again present my proposal, this time before the leadership of the Downtown Business Association. Jeff Andrews was president of the DBA then and present at that meeting. He worked tirelessly to bring the idea to fruition, soliciting funds and producing materials. In my opinion, the Civil Heritage Trail is his success, and so I was deeply honored when he asked me to stand with him for the ribbon cutting in 2013. While no red line (yet) marks the trail's path, visitors to Montgomery can now encounter hundreds of years of American history in a single afternoon walk, thanks to the efforts of the Downtown Business Association.

In the years since the Civil Heritage Trail was dedicated, an important question has been posed to me several times: Why compare the history of a group of people seeking freedom to the history of a group of people who opposed them? The Freedom Trail tells the story of one people with one aspiration. The Civil Heritage Trail, on the other hand, follows simultaneously the stories of two peoples working at cross-purposes with one another. What individual trail can be walked by footsteps directed toward such different destinations? What single narrative can tell both stories fairly and at once?

In my own mind, this question is the precise reason why we need the Civil Heritage Trail. Strife occurs when disparate people with conflicting stories battle with one another so that one version of the story can win. But if our experiment in democracy is to survive, we must not continue fighting over ownership of our history. Rather, we must endeavor to forge a new future that everyone can share equally. Our national motto is "E Pluribus Unum"—"out of many, one." The ethnic, cultural or religious unity of other nations is not our focus. Instead, we are held together by a shared commitment to liberty. When we call America a "melting pot," we mean that people come to this place from all over the world, bringing their own histories with them and adding to our collective story. The narrative that emerges from all of us is constantly reevaluated as we try to understand it from the perspective of other participants. This unity exists as a kind of tension, an ongoing interplay between the viewpoints of hundreds of millions of people nationwide. That tension is difficult to hold in balance (perhaps more so today than at any time since the Civil War itself), but we have constantly endeavored to add complexity to our self-understanding. If the story of America can be imagined as a song, then new voices—those of women, African Americans, Native Americans, Asian Americans, Hispanics and others—have slowly, but surely, been added to the chorus, creating sublime new harmonies in the process. No American should ever again be forced to sit by silently as our harmony devolves into a simple melody that no one wants to sing. The song—the story—must belong to everyone, even the parts that conflict.

The Civil Heritage Trail tells a difficult story. On the steps of the Alabama State Capitol is a bronze star marking the spot where Jefferson Davis was sworn in as president of the Confederacy. A century away in time, but only inches away in space, Martin Luther King addressed thousands who had marched from Selma to Montgomery in the name of civil rights. Each of these events is a critical component of American history, despite the differing

MONTGOMERY, ALABAMA

The Civil Heritage Seal provides a recognizable symbol for the trail. *Downtown Business Association.*

trajectories they proposed. In this time of discord facing the United States, we do well to remember our national story has been told by strongly dissenting voices since the days when patriots dumped tea in Boston Harbor. "One" can only be created from "many" by deliberate and dedicated action. Do we still have the collective will to keep forging? I very much hope so.

Teddy Roosevelt—descended from northern industrialists and southern plantation owners— embarked on a goodwill tour of the South in 1905, striving to repair wounds that had festered since 1865. While in Montgomery, the president remarked, "Poor indeed would be the soul of a man who did not leave Montgomery a better American than he came into it."[3] I hope that by presenting our shared and complex history for all to experience, the Civil Heritage Trail will aid in the forging of better Americans for countless generations to come.

JEFF DEAN

UNION STATION

MARY ANN NEELEY

On May 6, 1891, the citizens of Montgomery, Alabama, turned out en masse for the long-awaited opening of Union Station and its companion train shed. Parading through town were flower-bedecked carriages and dandies with their young ladies equally adorned. Over forty passenger trains entering and leaving Montgomery daily attested to the exceptional role trains played in people's lives and the monetary power passengers wielded. Their goodwill was a necessity to the railroads, and Union Station epitomized the determination the railroad lines were displaying for earning and keeping the relationship amiable.

The story begins before then. During the Civil War, the city served as a major railhead for the shipping of soldiers and materials to the battlefields. Following the war, railroad building began again in earnest, and with the acquisition of the South and North Railroad by the Louisville and Nashville (L&N) Railroad, connections between south Alabama and the northern region were completed. As the economy recovered from the war and Reconstruction, Montgomery assumed a role as the wholesale center for many businesses. Six railroads come through Montgomery: the L&N, Western of Alabama, Central of Georgia, Seaboard Airline, Mobile and Ohio and the Atlantic Coast line.

As railroad passengers increased, they became more vocal with their discontent with conditions. This was true all over the state as well as in other parts of the country. During the mid-1880s, a small Italianate station on Water Street served Montgomery, but there was no shed to

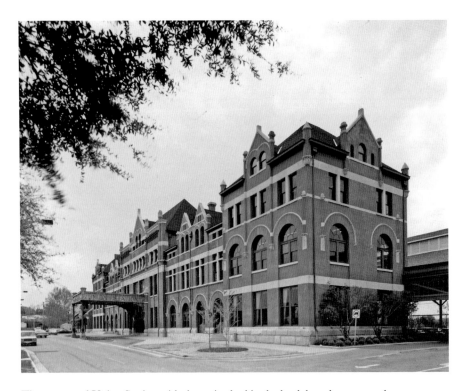

The renovated Union Station with the train shed in the back has always served Montgomery with beauty and grace. *Landmarks Foundation.*

protect passengers from the elements. Complaints grew louder, and finally in 1888, a small shed was built that temporarily quieted the clamor. However, the L&N and other railroad lines realized the dire need for an adequate station and arranged for the construction of a station to begin.

Benjamin Boswell Smith designed the new, monumental station, and the Louisville and Nashville Engineering Department produced the working drawings. Incorporating a variety of materials, the building design was much like the eclectic look of the late Victorian style. Undergirded with a rusticated limestone base, the brick structure incorporated both Romanesque and Chateauesque characteristics. Stained-glass windows, a copper marquee, elegant Romanesque rounded windows and front doorway and terra-cotta details bespoke the railroad's intention of providing its passengers with beauty and grand fashion.

In 1896, the Supreme Court of the United States had ruled in a specific railroad case that segregation was legal; the political climate in the South in that day and time was exemplified in the design of the new train facility.

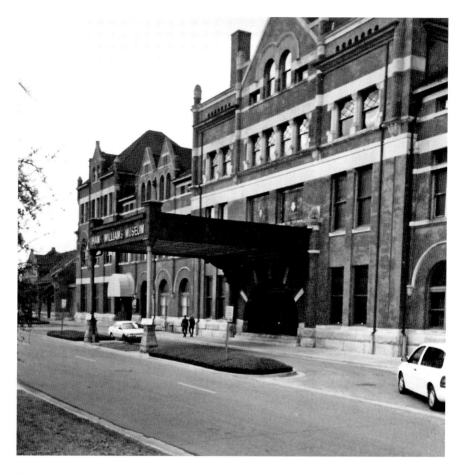

Union Station serves as the Convention and Visitors Bureau Welcome Center, a commercial lease space, meeting areas and a restaurant. *Landmarks Foundation.*

The "White Only" waiting room and dining room had companion pieces in "Colored Only" features of the same.

At the rear of the station is the National Historic Landmark Train Shed. It is one of very few of its kind still standing. Constructed of iron and timbers, its phoenix trusses reflect the influence of late nineteenth-century technology that is also found in the Eiffel Tower and the Brooklyn Bridge. The six-hundred- by seventy-eight-foot shed sheltered four of the six tracks that brought passenger trains in and out of the city.

An active, bustling place, Union Station opened at the same time that the United States declared war on Spain. Therefore, much of its early use was for the movement of troops. Again, during World Wars I and II and

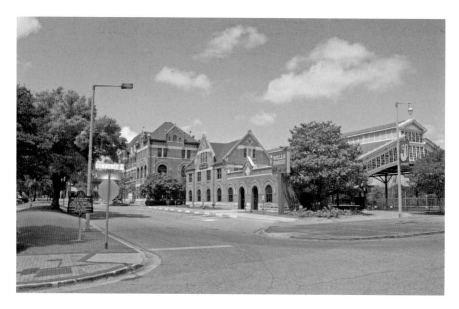

A full view of Union Station shows the historic train shed. Events such as music, food and art festivals are held in the shed. *Landmarks Foundation.*

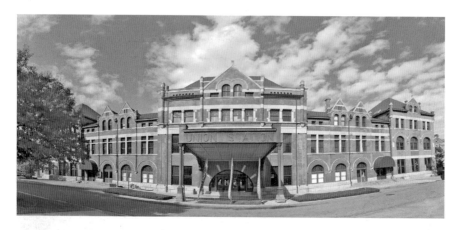

A front view of Union Station shows the wings, the copper canopy and the imposing nature of the building that welcomes visitors to Montgomery. *Montgomery Convention and Visitors Bureau.*

the Korean War, the depot witnessed mass movements of men coming for training and departing for war. The famous, infamous and ordinary have traveled through Union Station. Some of the more distinguished include President Theodore Roosevelt, President-elect Franklin D. Roosevelt, the Wright brothers, and F. Scott and Zelda Fitzgerald.

By the late 1970s, passenger trains had given way to automobiles, buses and planes, so Union Station was no longer the exciting and bustling place it once was. Many depots were demolished by the railroad lines, but then mayor Earl James insisted that the City of Montgomery become the guardian of the facility.

In 1982–83, developer Jim Wilson purchased and restored the building for his corporate offices. In 1999, the City of Montgomery acquired it with plans to jointly use it with the Montgomery Area Chamber of Commerce Convention and Visitors Bureau and as a part of the riverfront development projects.

Right: The restoration of Union Station included stripping many years of paint and repairing extensive damage in order to bring it back to its original grandeur. *Landmarks Foundation.*

Below: The restoration of the historic interior of Union Station included many original elements; the interior acts as the Montgomery Visitor Center. *Montgomery Convention and Visitors Bureau.*

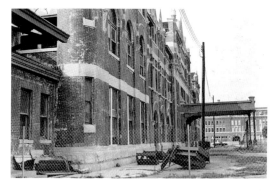

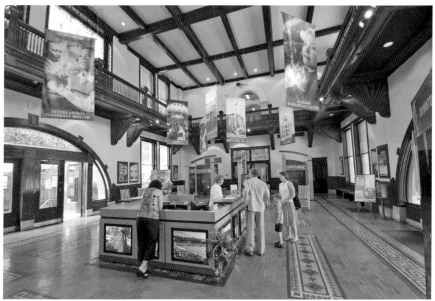

Today, it serves as the Montgomery Area Visitor Center and the Stop, the Union Station gift shop, along with other business offices. The train shed is often the scene of parties, wedding receptions, concerts and a variety of other events.

RIVERFRONT PARK AND *HARRIOTT II* RIVERBOAT

KEN REYNOLDS

As civilization has developed through time, the recurring need to have settlements near water has been a constant motif. And so it was when, prior to colonization by European settlers, the Alibamu and Coushatta Indian tribes settled on opposite sides of the river at the sweeping bend of what is now called the Alabama River, at the location of present-day Montgomery, Alabama. This location features the high red bluff visible today in downtown Montgomery.

The Coosa, Alabama and Mobile Rivers are essentially a single river whose name changes at the confluences of major tributaries. The Alabama River is formed by the joining of the Tallapoosa and Coosa Rivers six miles north of present-day Montgomery. The Alabama River flows west to Selma and then turns southwest until it merges with the Tombigbee River forty-five miles north of Mobile to form the Mobile and Tensaw Rivers, which ultimately discharge into Mobile Bay and, farther south, into the Gulf of Mexico.

The earliest known Europeans to travel through the region were Hernando De Soto and the members of his expedition, who, in 1540, camped for a brief period in the Indian village of Towassa, located atop the red bluff. Also called Hostile Bluff or Thirteen Mile Bluff, this spot became a key strategic point in colonial days.

Later settlers from the Carolinas traveled down the Alabama River in 1679. However, the first permanent settler, James McQueen, did not arrive

in the area until 1716, and the first commercial venture in or around present-day Montgomery, a trading post, was established in 1785.

The defeat of local and regional Indian tribes at the Battle of Horseshoe Bend by forces led by General Andrew Jackson effectively ended the Creek Indian War and subsequently the Indian threat in the territory. Treaties with the Indians opened up vast areas for European/American exploration and settlement.

The first significant group of settlers to arrive along the banks of the Alabama River at what is now Montgomery was headed by General John Scott. The group founded Alabama Town approximately two miles downstream from the current downtown location. In the area located in what is now the eastern section of downtown Montgomery, Andrew Dexter Jr. founded New Philadelphia. General John Scott later established East Alabama Town on land adjacent to New Philadelphia. As the population grew along the banks of the Alabama River and the two towns prospered, rivalries were set aside, and on December 3, 1819, they merged to form the town of Montgomery.

It is interesting to note that each of Alabama's capitals—St. Stephens, Huntsville, Cahawba, Tuscaloosa and Montgomery—are or were river towns.

Just as the Alabama River played a key role in the location and founding of Montgomery, it was to also play a major role in the new town's development and growth.

The rich soil of what was to become known as the Black Belt led to the establishment of an agrarian society in which cotton was king. In 1821, the first riverboat, *Harriott*, arrived in Montgomery, ushering in a new age of growth and prosperity as the Alabama River became a major upriver conduit for goods received from Mobile, New Orleans, the East Coast and Europe. Millions of bales of cotton were shipped downriver from Montgomery's wharf to the textile mills of England in return for manufactured goods and letters of credit that sustained a growing merchant class and landed aristocracy. The ability to promote and extend traffic both upstream and downstream made Montgomery prosperous as a hub for commerce, as well as the center for the state and later Confederate governments.

By the 1840s, the demand for cotton was also driving a booming slave trade in Montgomery and throughout the South. Steamboats carried slaves upriver from Mobile and New Orleans. At its peak, the slave market in Montgomery received hundreds of slaves daily, turning Montgomery into a principal slave-trading center in Alabama.

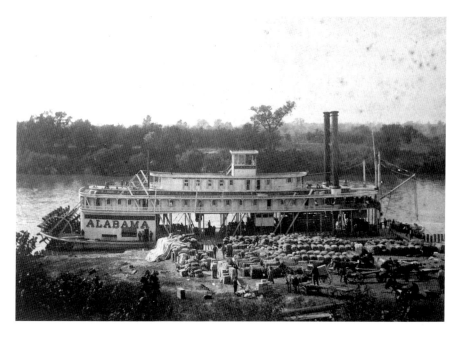

This historic view shows the *Alabama* riverboat being loaded with cotton and other cargo. After being loaded, it went on its way to the port of Mobile. *Montgomery County Historical Society.*

Cotton slides were used to move bales of cotton from the higher elevation of Montgomery down the bluff to the riverboats for loading and transport. In 1879, the tunnel at the end on Commerce Street was constructed to permit horse-drawn wagons to deliver bales of cotton to the riverfront without having to cross over the railroad tracks.

During and after the Civil War, railroads began to compete with steamboats for passengers and cargo, and though the boats held their own for the rest of the nineteenth century, the railroads won the battle. Travel by rail was faster and more dependable. Steamboats continued to carry large amounts of cotton, but when the boll weevil arrived and began to destroy the cotton crop, the days of river commerce were numbered.

Early in the twentieth century a new form of commerce began to emerge as the Alabama Power Company began building hydroelectric dams on the Coosa and Tallapoosa Rivers. The effect of damming the Alabama River has been significant. Lakes and recreational areas have been created, annual flooding of vast areas of agricultural lands has been curtailed or controlled and recreational venues and activities bring tourism dollars and commercial enterprises to metropolitan and rural areas alike.

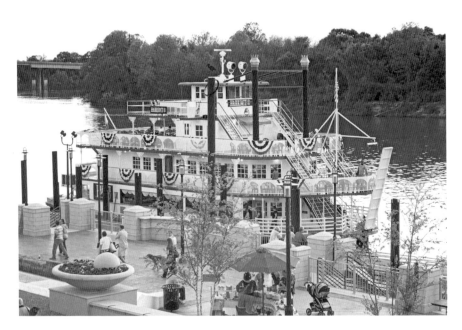

Above: The *Harriott II* is ready to go down the Alabama River from Riverfront Park. Passengers enjoy dinner, drinks and music. *Montgomery Convention and Visitors Bureau.*

Left: The entrance from Commerce Street through the tunnel originally served for loading cotton and other goods. Today, it serves as the entrance to Riverfront Park and has this visitor very excited. *Cynthia Jancaterino.*

Today's urban redevelopment initiative has transformed Montgomery's downtown and riverfront into the first certified entertainment district in the state of Alabama, the Lower Commerce Street Historic District. Once empty mercantile warehouses now cater to a new generation of urban dwellers as the renovated buildings provide space for trendy restaurants, bars, art galleries, office space and loft apartments.

The former Western Railroad of Alabama Freight Terminal, built in 1898, is now home to Riverwalk Stadium and the Montgomery Biscuits, a AA franchise of the Tampa Bay Rays.

Riverfront Park Boat Landing and home of the *Harriott II* is a popular destination for fun evenings and afternoons on the Alabama River. *Landmarks Foundation.*

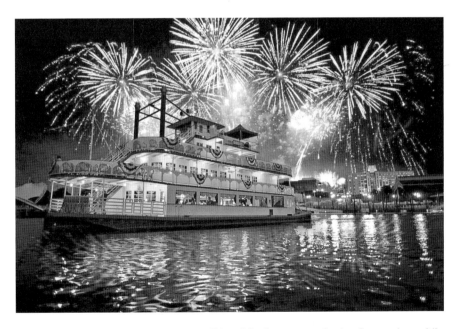

The *Harriott II* cruises down the Alabama River full of passengers having fun evenings while fireworks illuminate the night. *Montgomery Convention and Visitors Bureau.*

A short walk through the historic 1879 tunnel brings locals and tourists to Montgomery's Riverfront Park. This unique downtown greenspace features a river walk along the banks of the Alabama River, a splash pad, the Sand Bar and one of Alabama's most unique concert and special event venues, the Riverwalk Amphitheater.

Riverfront Park also serves as the docking point for a new generation of riverboat plying the waters of the Alabama River, the *Harriott II*. One of the city's most popular attractions, the *Harriott II* offers regularly scheduled cruises on the scenic Alabama River; specialty cruises and private rentals are available. Dinner is served on Friday evenings (as well as on Saturdays during June and July). These excursions offer a delightful glimpse of times gone by as the paddle wheel turns, music plays and the banks of the river slide past, much as they did during the heyday of river travel on the Alabama River.

The *Harriott II*, Riverfront Park and a renovated downtown are all part of a modern downtown Montgomery that depends on the Alabama River, just as its past incarnations have.

COURT SQUARE
AND FOUNTAIN

CAROLE KING

As the heart and hub of downtown Montgomery, Court Square has witnessed many events that have changed the face and fate of the city and the nation. Today, the junction of the streets shows the convergence of the two founding villages of New Philadelphia, which was east to Goat Hill, and of Alabama Town, located closer to the river traffic. Montgomery's Court Square has been at the western end of Market Street, now known as Dexter Avenue. A wooden building and a later 1835 brick one served the populace as a courthouse until after the city became the state capital in 1846. Businesses, including those selling land, slaves, cotton and other goods, gravitated to Court Square for public sales and auctions in front of the courthouse. The area offered a convenient locale for the exchange of news and the gathering of crowds for parades and exhibitions. This practice continued after officials moved the county government to the corner of Washington Avenue and Lawrence Street.

When the city dug out the existing artesian well located in the vicinity of the courthouse, it created a basin and soon surrounded it with a decorative iron fence. Drivers watered their stock, and firefighters filled their buckets from what citizens referred to as the "Big Basin." Peddlers hawked their wares, and auctioneers barked prices as goods exchanged hands around this important city site. In answer to protest from citizens and the newspaper, and in a burst of civic pride, the city council in 1885 determined to beautify Big Basin, which had become, in *Montgomery Advertiser* editor W.W. Screws's

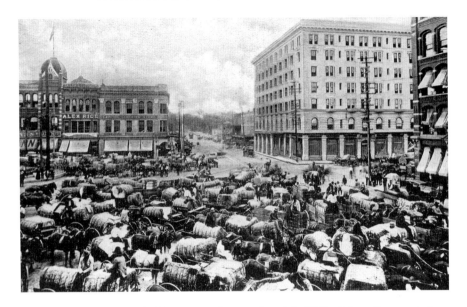

Court Square was crowded with wagons of cotton for sale in 1905. *Alabama Department of Archives and History.*

words, "the hog wallow in the Square."[4] With instructions from the city council and Mayor Warren S. Reese, Alderman T.H. Carr was sent north to search for a proper adornment for the Big Basin. Within a few days, he wired city officials: "I have bought the fountain, its weight is fifteen tons, and I think the people will be satisfied."[5] In September of that same year, a fountain pedestal and statuary arrived, having been cast by the J.L. Mott Iron Works of New York, along with an installation supervisor from the company. The form of a lady and of a swan originally topped the fountain, but a year later, the city replaced the ornament with Hebe, goddess of youth and cupbearer to the gods. Today, Hebe continues to crown the top and, with her attendants—babies and birds—reflects the proper fervor or frivolity of the moment, symbolizing the city's faith in its past and its future.

On the northwest corner of Court Square once stood the Exchange Hotel, built in 1846, when Montgomery gloried in its new role as Alabama's capital city. Designed by Stephen Decatur Button, architect for Montgomery's first capitol building, the Greek Revival–style Exchange Hotel quickly became noted for its cuisine and hospitality and thus found itself at the center of both social and political life. Known as the best hotel in town, the Exchange Hotel offered amenities like a fine-dining room and comfortable private rooms. Its out-of-town guests, as well as townspeople, took pleasure and comfort in an 1850s city ordinance decreeing that no longer could hotels, restaurants

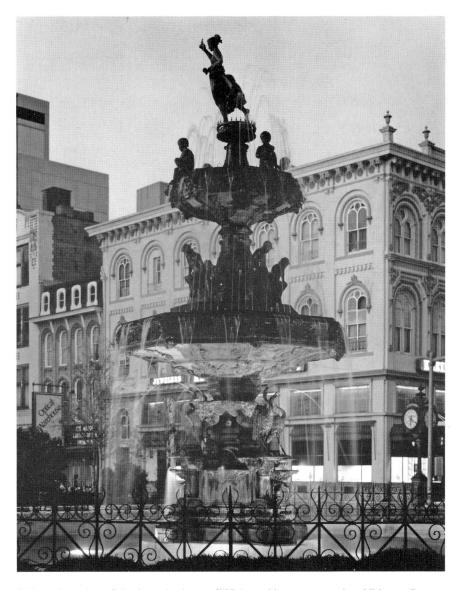

This modern view of the fountain shows off Hebe and her entourage in addition to Court Square and the Central Bank of Alabama–Klein Building. *Landmarks Foundation*.

and private dwellings toss their noxious wastes into the streets. Here, after the capitol burned in 1849, officials conducted much of the state's business, and in the early months of 1861, the Confederate government issued many important decisions from the hotel suites. President and Mrs. Jefferson Davis lived at the Exchange Hotel until their house on Bibb Street was ready for

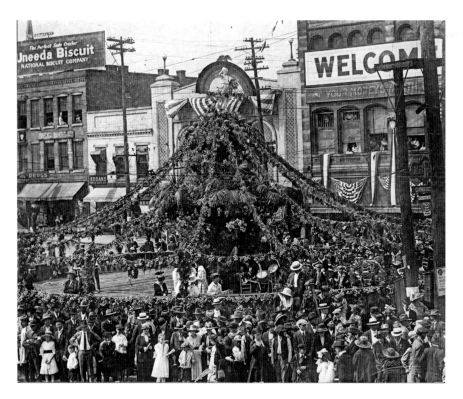

The fountain at Court Square was decorated for the World War I victory parade for the return of the 167th Infantry Regiment in 1919. *Alabama Department of Archives and History.*

occupation in 1861. Following an 1885 renovation, the local paper proclaimed it an imposing, if not magnificent, building "whose boudoirs rival those of an Egyptian Queen."[6] In 1905, the hotel owners decided to demolish the old Exchange Hotel and build in its place the New Exchange, a modern, up-to-date facility. For many years, it, too, served as a social and political hub, but by the mid-1970s, both it and its reputation had suffered the ravages of time. The building disappeared from Court Square in 1974.

One of Montgomery's early three-story brick structures, the Winter Building, located on the southeastern corner of Court Square, dates from the early 1840s. It was built by Georgian John Gano Winter for a branch of his St. Mary's Bank. At the time of the Civil War, it housed a clothing store, daguerreotype gallery, professional offices and the Magnetic Telegraph Company. From this telegraph company in the Winter Building the Confederate government sent the telegram to its forces in South Carolina, empowering them to remove the Federal troops from Fort Sumter, an order that started the Civil War. Later, as

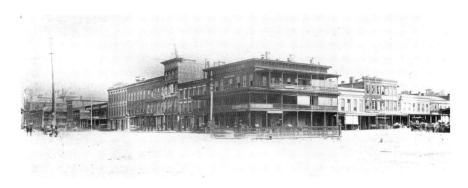

The Winter Building and South Court Street at Court Square were stately around 1885. *Alabama Department of Archives and History.*

war news came in over the telegraph wires, operators read the results of battles and their casualties to an anxious public gathered in Court Square below the Winter Building's galleries.

The handsome Renaissance Revival structure, originally known as the Central Bank of Alabama, was built on the northeast corner at Dexter Avenue in 1855. The bank's president, William Knox, hired architect Stephen Decatur Button, the designer of Montgomery's first state capitol building, to plan a structure for Knox's thriving enterprise. Button utilized ideas from fifteenth-century Venetian palaces while incorporating newly developed cast-iron decorative elements in the façade. The Central Bank was the first to lend money to the Confederate government and, at the end of the war, went into receivership. Throughout the rest of the nineteenth century into the early twentieth, other financial institutions occupied the building. In the early 1920s, Klein and Son Jewelers acquired the Central Bank building and modified its street-level windows and interior spaces. Inside, shoppers found magic and beauty in the dark-stained wooden cases where diamonds sparkled in the changing light, flat silver gleamed and fine china and crystal encouraged young brides to continue the elegant table-setting traditions passed down from one generation to the next. In the 1930s, Klein and Son purchased a large street clock and placed it at the corner of Dexter and North Court Streets. The clock soon became the official timepiece for all of downtown, and today, the well-known sidewalk clock is a popular landmark in itself.

The Moses Building, constructed in the 1880s as Montgomery's first skyscraper, was once located on the northeast corner, at the convergence of Commerce and North Court Streets, and housed the Moses Brothers

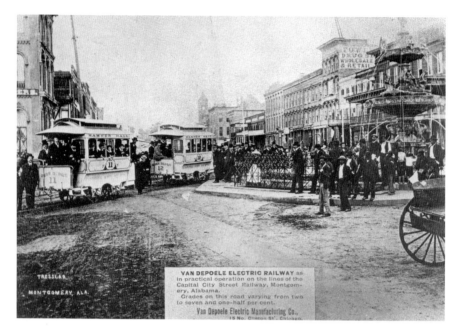

Cars of the Capitol City Street Railway met at the Court Square fountain in downtown Montgomery, Alabama, in 1886. *Alabama Department of Archives and History.*

Banking and Realty Company, the city's largest business. This building was replaced in 1907 by the current First National Bank/Regions and, after several "facelifts," still dominates that corner of Court Square. Today, four of the lions' heads that had originally adorned the cornice of the building are displayed in the park created when the city redirected the flow of traffic through Court Square during urban renewal.

From this northeast corner of Court Square in 1886, the nation's first electric streetcar system, the "Lightning Route," was put into operation by the Capital City Street Railway. The trolley could move at six miles per hour, uphill and down, and gave impetus to the development of the suburbs and public parks away from the inner city. In 1887, the company inaugurated electric services on its entire fifteen-mile system, thus becoming the first all-electric operation in the Western Hemisphere. After fifty years of providing reliable service, the Lightning Route made its last run on March 8, 1936, with throngs gathered in Court Square to say goodbye.

As the town grew and new modes of transportation appeared, traffic became an ever-increasing problem. Sulkies, trolleys, cotton wagons, bicycles and pedestrians vied for the right of way on busy Court Square. Montgomery Street traffic ran peacefully where the commercial district

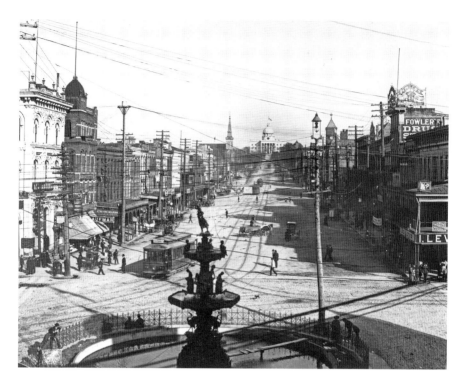

In 1905, Court Square was a busy intersection with streetcars, electric lines and people on their busy ways. *Alabama Department of Archives and History.*

merged into the residential section to the west and on to the Five Points business district at the Cottage Hill neighborhood. In the 1920s, traffic became such a problem around Court Square that the city found it necessary to station a policeman in a tower on the edge of the fountain to control signals for pedestrians, trolleys and automobiles as they circled the square and crossed its bustling streets.

On the cool evening of December 1, 1955, a tired Mrs. Rosa Parks left her job as a seamstress at the Montgomery Fair Department Store on Dexter Avenue and wearily walked to the north side of Court Square to catch her bus home. She boarded a city bus and sat in the front of the designated colored section. The whites-only section in the front of the bus filled up, and a white man was left standing. The bus driver demanded that Parks and three other patrons in the colored section give up their seats so the white man could sit. The other three people moved, but Parks refused to give up her seat. The driver contacted the local police, and she was arrested with the charge of disorderly conduct filed against her. Four days later, she was found guilty, and

the Montgomery Bus Boycott began. For 381 days, Montgomery's African American community boycotted the city bus line by organizing other kinds of transportation or walking. The boycott continued strong for over a year, until the U.S. Supreme Court ruled that the segregation of bus services was unconstitutional.

By the 1950s, many changes had occurred. Paved streets and sidewalks linked the sides of Court Square. Different businesses, including loan companies, furniture stores, department stores, cafés and a bakery, lined the

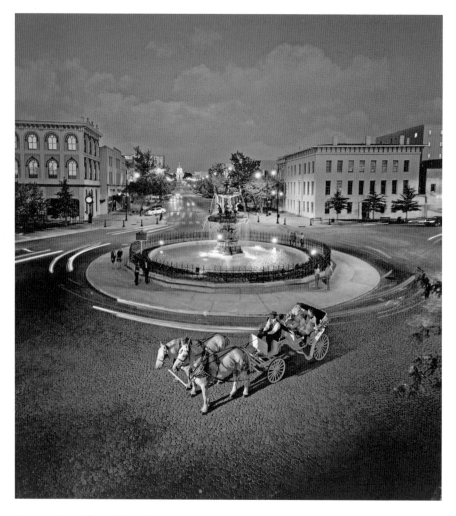

A romantic carriage ride makes nightlife glamorous at the fountain in Court Square. *Montgomery Convention and Visitors Bureau.*

western side of South Court Street. On the morning of March 25, 1965, a crowd of around twenty-five thousand arrived in downtown, finishing its march from Selma to Montgomery. The marchers streamed around Court Square and up Dexter Avenue, past Dexter Avenue King Memorial Baptist Church, to the steps of the capitol, where hundreds of armed law officers would not allow them to set foot on state property. Dr. Martin Luther King made his famous speech from the back of a truck parked at the bottom of the steps.

Throughout the decades, through advances in transportation, disputes, wars, rising and declining businesses and changing social opinions, this area at the intersection of Montgomery's two original villages—New Philadelphia and Alabama Town—continues to be the center of downtown life. Even though the courthouse is no longer located on this site and the area is no longer truly square, it will forever be known as Court Square.

ROSA L. PARKS LIBRARY, MUSEUM AND CHILDREN'S WING

FELICIA A. BELL, PHD

Rosa Louise McCauley was born on February 4, 1913, in Tuskegee, Alabama. When she was two years old, her family moved to Pine Level, Alabama, to live with her maternal grandparents. Her mother, a schoolteacher, taught Rosa at home until age eleven when she moved to Montgomery to live with her aunt. She enrolled in a private school, the Montgomery Industrial School for Girls, where she cleaned classrooms to pay her tuition. Later, she attended Booker T. Washington High School but was forced to leave to take care of her sick mother and grandmother.

In 1932, Rosa McCauley married Raymond Parks. They remained married until his death in 1977. Raymond was a barber by trade and an active member of the National Association for the Advancement of Colored People (NAACP). He supported his wife's desire to return to school, and she received her high school diploma in 1933.

On December 1, 1955, at the age of forty-two, Rosa Parks made a decision that would change the course of history in America. She worked as a seamstress at the Montgomery Fair Department Store. As she headed home at the end of her work day, she boarded a city bus and sat at the front of the colored section. Jim Crow laws were in effect all over the South. Segregation was a part of everyday life, including on public transportation.

The bus had reached the stop near Montgomery and Lee Streets and the Empire Theater. The section in the front of the bus designated for "whites only" had filled, and a white man was left standing. The bus

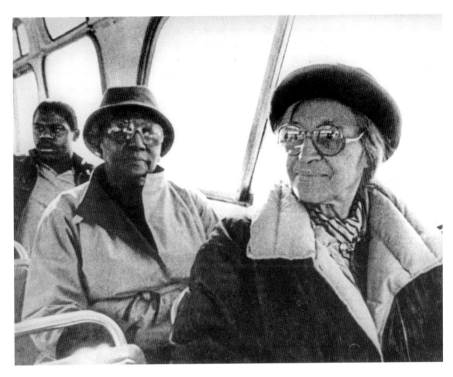

On December 4, 1985, Mrs. Johnnie Carr and Mrs. Rosa Parks reenacted the Bus Boycott in Montgomery, Alabama. *Alabama Department of Archives and History.*

driver demanded that Parks and three other patrons in the colored section give up their seats so the white man could sit. The other three passengers moved. However, Parks refused to yield her seat simply by telling the bus driver, "No." As a result, she was arrested when he contacted the police and filed charges against her. Four days later, Parks was found guilty of disorderly conduct. The African American community responded with a boycott of all Montgomery city buses that lasted 381 days.

Today, the Rosa Parks Museum at Troy University–Montgomery is located where the Empire Theater once stood and where Parks was arrested, on the corner of Montgomery and Lee Streets. The 7,000-square-foot museum occupies the first floor of a three-story building. The space includes permanent and temporary exhibits; a 103-seat, 2,200-square-foot multimedia auditorium; and two state-of-the-art classrooms with distance learning capabilities.

The museum's exhibits tell the story of the bravery and courage that was required of Parks and other civil rights movement leaders. Its collection

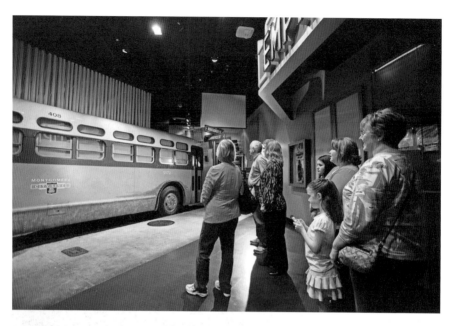

Above: Visitors to the Rosa L. Parks Museum can see a replica of the city-operated bus where she refused to give up her seat to a white man. *Montgomery Convention and Visitors Bureau.*

Left: The Rosa L. Parks Museum stands where she was taken off the bus at the corner of Montgomery and Moulton Streets. *Montgomery Convention and Visitors Bureau.*

includes a variety of artifacts, including historical documents related to the Montgomery Bus Boycott, a restored 1955 Montgomery city bus, a restored 1955 station wagon known during the boycott as a "Rolling Church," over five hundred African American magazines from the 1950s and 1960s and oral history interviews from individuals who lived in Montgomery during the tumultuous civil rights movement.

The Rosa Parks Museum Children's Wing features the award-winning "Cleveland Avenue Time Machine," designed to give visitors a multimedia experience about the Jim Crow South. The Research Center is located on the second floor of the Children's Wing and is available for use by the faculty and students of Troy University, visiting scholars and the general public.

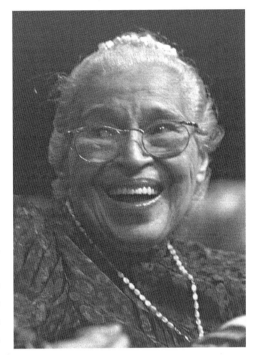

Rosa L. Parks, civil rights pioneer, smiles in this photograph taken many years after the Montgomery Bus Boycott. *Dexter Avenue King Memorial Baptist Church.*

Through its exhibits, educational programs and historical resources, the Rosa Parks Museum at Troy University–Montgomery continues to serve as a platform for scholarly dialogue, civic engagement and social activism for today's civil rights movement. For more information, please contact the museum at 334-241-8615, visit us online at www.troy.edu/rosaparks/museum or follow us on Facebook, Twitter and Instagram.

FREEDOM RIDES MUSEUM AT THE GREYHOUND BUS STATION

DOROTHY WALKER

The Freedom Rides Museum is located inside the historic Montgomery Greyhound bus station where, in 1961, significant events occurred that became a turning point for the civil rights movement. The arrival of the Freedom Riders and the subsequent riot at the Montgomery Greyhound bus station changed the course of civil rights struggles in the Deep South. The attack on the Freedom Riders at the Montgomery Greyhound bus station on May 20, 1961, compelled the federal government to become involved in and champion the cause of civil rights.

The Alabama Historical Commission restored the former Greyhound bus station and opened it as the Freedom Rides Museum in 2011. This marked the fiftieth anniversary commemoration and created an opportunity for deeper immersion in the richly layered history surrounding the events that occurred at the bus station. In 2012, the Alabama Historical Commission and the General Services Administration were recognized for their partnership in preserving the building with an award from the National Trust for Historic Preservation.

The Montgomery Greyhound bus station is one of those ordinary buildings that has been rendered extraordinary by the American struggle for equality in the mid-twentieth century. On May 20, 1961, a biracial group of twenty-one college students from Nashville risked their lives to end racial segregation in interstate travel. They were trained in Gandhian nonviolent protest methods, but when they arrived at the bus station, they were met

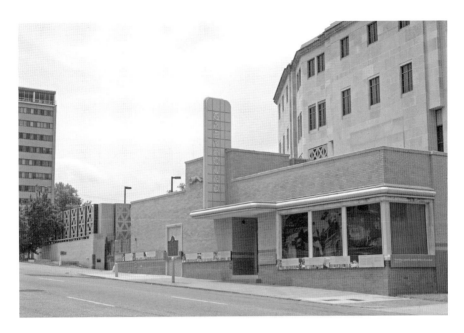

This is a current view of the Freedom Rides Museum at the Greyhound bus station on South Court Street. *Landmarks Foundation.*

by an angry, police-sanctioned mob. The violence that ensued resulted in a marked turn for the young administration of President John F. Kennedy and for Montgomery's business community.

The legal desegregation of interstate travel began in 1944 with the arrest and conviction of Irene Morgan in Middlesex, Virginia, for refusing to give up her seat on an interstate bus, according to Virginia's segregation laws. Morgan appealed her conviction to the U.S. Supreme Court, and in 1947, in the case of *Morgan v. Virginia*, the Supreme Court outlawed Virginia's state law enforcing segregation on interstate buses. This ruling inspired the Congress of Racial Equality (CORE) to embark on the Journey of Reconciliation. The riders, all trained in Gandhian principles of nonviolence, met with resistance as they tried to integrate buses from Washington, D.C., through Virginia, North Carolina, Tennessee, Kentucky, Ohio and West Virginia.

In 1958, a young Howard University law student, Bruce Boynton, was arrested in Richmond, Virginia, for trying to integrate a Greyhound bus station lunch counter. Boynton appealed his arrest and conviction of violating Virginia's segregation laws to the U.S. Supreme Court. In 1960, in *Boynton v. Virginia*, the Supreme Court extended the *Morgan* ruling to bus terminals used in interstate bus service. However, as southern states refused to abide

by either ruling, African Americans continued to be ejected or arrested when they tried to integrate facilities.

Based on the Supreme Court ruling in the *Boynton* case, CORE set out on another Freedom Ride—this time coming into the Deep South. On May 4, 1961, an integrated group of Freedom Riders left Washington, D.C., on a journey to integrate interstate facilities. The riders' goal was to get to New Orleans, Louisiana, by May 17, the anniversary of the *Brown v. Board of Education* ruling.

As the group traveled through Virginia and North Carolina, they encountered little resistance. But as the Freedom Riders entered Rock Hill, South Carolina, they met with physical and verbal attacks from bystanders and onlookers opposed to integration. In Atlanta, Georgia, the Freedom Riders met with Dr. Martin Luther King Jr., who warned them that there were Klan members and supporters planning an attack on the group in Alabama.

On Mother's Day, Sunday, May 17, 1961, the Freedom Riders arrived in Anniston, Alabama. There they were met by hundreds of Klansmen and their supporters, who viciously attacked the Freedom Riders and set the Greyhound bus on fire. Later that day, at the Trailways bus station in Birmingham, another mob of Klansmen and their supporters attacked the Freedom Riders.

The attacks in Alabama left the Freedom Riders battered and bruised but determined to continue their journey. Through a series of negotiations between local, state and federal officials, led by John Siegenthalar, aid to Attorney General Robert Kennedy, the CORE Freedom Riders were forced to abandon the rides and flew back to New Orleans from Birmingham.

Days later, college students in Nashville, part of the Nashville Student Movement, vowed to come to Alabama to continue the Freedom Rides. The students boarded buses to Birmingham. After arriving in Birmingham, they were welcomed by civil rights leader Reverend Fred Shuttlesworth, who immediately set out to assist the students with continuing the Freedom Rides. The segregationist leadership of Birmingham's local law enforcement set out to stop the students from continuing to ride, even going so far as to load them into police vehicles and escort them back to the Tennessee-Alabama state line. The student Freedom Riders not only made their way back to Birmingham, but other students from Nashville came with them to join the rides. The Kennedy administration and Alabama governor John Patterson agreed to provide protection from the state highway patrol while the Freedom Riders traveled from Birmingham to Montgomery. However,

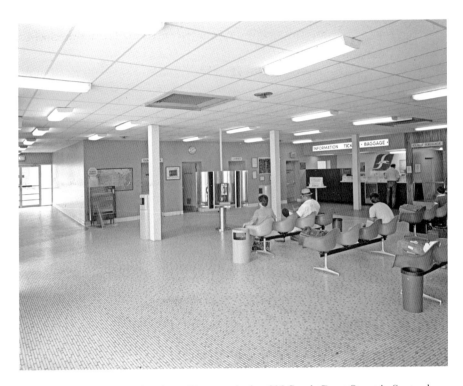

The waiting room of the Greyhound bus terminal at 210 South Court Street in September 1983 shows lots of open space for arriving and departing passengers. *Alabama Department of Archives and History.*

the state highway patrol did not have jurisdiction within the Montgomery city limits.

On Saturday, May 20, twenty-one student Freedom Riders from Nashville, Tennessee, arrived in Montgomery, Alabama. At the Greyhound bus station, the Freedom Riders were met by an angry mob of two to three hundred people wielding bats, chains and metal pipes. The police arrived, but it became clear that their only actions would be to direct traffic. Three hours after the riot began, tear gas dispersed the mob. Five hours after the beginning of the riot, order was finally restored. Twenty people, including Freedom Riders, members of the press and bystanders, were injured. State officials, including Governor Patterson, denounced the Freedom Riders as "outside agitators" and "fools" for coming into the state to stir up trouble.[7]

On May 21, 1961, the Freedom Riders took refuge in the First Baptist Church on North Ripley Street, where they were joined by Dr. Martin Luther King Jr. and 1,500 activists and members of the congregation.

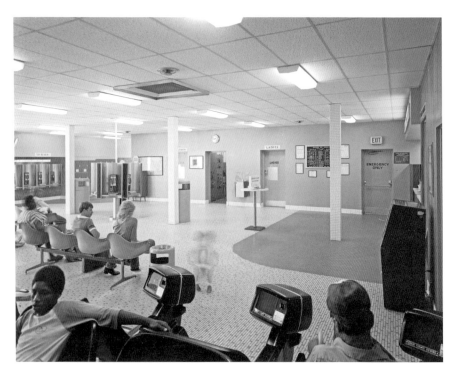

The waiting room of the Greyhound bus terminal as it appeared in 1983. *Alabama Department of Archives and History.*

Outside, a violent mob grew larger. Bricks were thrown through the church's stained-glass windows, fires were set and tensions ran high. From a telephone in the basement of First Baptist Church, Dr. King relayed his fears of further violence to Attorney General Robert Kennedy. Dr. King urged the administration to act once more to protect the rights and lives of the Freedom Riders. Alabama National Guardsmen, having been federalized by President John F. Kennedy, drove away the mob gathered outside the church. With the threat abated, the individuals assembled inside the house of worship continued with a planned Freedom Rally, lifting their voices in song, joining hands with their like-minded brothers and sisters and steeling themselves for the events of the coming days.

Judge Johnson issued an order allowing the Freedom Riders to continue, and on May 24, 1961, the Freedom Riders, under the protection of federal troops, left Montgomery to continue the ride to Jackson, Mississippi. Upon reaching Jackson, the Freedom Riders were arrested and given thirty-day sentences. Their courageous actions gained international attention and

inspired hundreds of others from across the nation to join rides and come to Jackson, Mississippi, between May and September 1961. With pressure from President John F. Kennedy, the Interstate Commerce Commission issued a ruling effective November 1, 1961, to integrate all interstate facilities and modes of transportation, including buses, trains and airports.

The historic Greyhound bus station in Montgomery stands as a testament to the effectiveness of direct-action, nonviolent protest by ordinary citizens in garnering broad support for the civil rights movement from civil rights leaders.

The Freedom Rides Museum honors the courageous Freedom Riders, who stayed committed to nonviolence even in the face of violent opposition. The museum features an award-winning exterior exhibit that chronicles the story of the Freedom Rides through words and images of the Freedom Riders, their supporters and those opposed to integration.

The museum also features interior exhibits that place the Freedom Rides within the broader context of the civil rights movement. Visitors are invited to engage in the details of individual stories of the Freedom Riders and hear their experiences in their own words. Visitors also understand the way buildings in the South were designed for segregation during the Jim Crow era and how this affected the day-to-day lives of both races.

The Montgomery Greyhound bus station, as the site where the Freedom Riders were attacked, stands as a testament to the resilience of the human spirit. It has been designated as a historic site and is surrounded by historic buildings that bore witness to the events of May 20, 1961. Across the street from the bus station stands the historic Moore Building, a 1942 office building, where Virginia Durr, a civil rights supporter, witnessed the attack on the Freedom Riders. Next to the Freedom Riders Museum sits the U.S. District Courthouse where Judge Frank M. Johnson's favorable rulings in civil rights cases, including for the Freedom Rides, prompted officials to rename the historic building in his honor.

On November 1, 1961, new Interstate Commerce Commission regulations went into effect. The Freedom Riders had won an unqualified national victory. No longer did African Americans have to sit separately or use separate waiting rooms and restaurants. Equally significant, the Kennedy administration forcefully sided with the protestors. Washington sent federal marshals to protect the Freedom Riders in Montgomery and enforced existing laws and court decisions against racial discrimination. The Freedom Rides were a watershed event, "a psychological turning point in our whole struggle," said Reverend Dr. Martin Luther King Jr.[8]

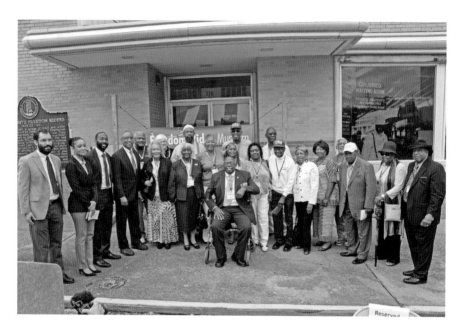

Freedom Riders and others who returned to Montgomery from all over the country to celebrate the fifty-fifth anniversary in May 2016 pose in front of the bus station. *Elvin Ling, Alabama Historical Commission, Black Heritage Council.*

The Freedom Rides Museum stands as a testament to 438 ordinary people who did an extraordinary thing. They risked their lives and their freedom to bring justice to our nation.

DEXTER AVENUE KING MEMORIAL BAPTIST CHURCH

RALPH J. BRYSON, PHD; DEACON
VIRGINIA GARY; ZELIA STEPHENS
EVANS, EDD; AND JAMES T. ALEXANDER

A favorite adage printed in the Sunday service bulletin for Dexter Avenue King Memorial Baptist Church reads, "Hope is praying for rain; Faith is carrying an umbrella." Faith and hope are indeed two of the attributes of this church community, whose members have, for over one hundred years, been "servant leaders in the cause for justice and equality."[9]

Dexter King Memorial Church traces its beginnings to January 1877, when trustees purchased a small frame building that had previously been used as a slave pen in antebellum Montgomery: "In a shabby building where odors of the filth and signs of the horrors of slave life were evident the seed of Dexter was sown."[10] The slave pen was used for worship services and then torn down. The work began on the present building in 1883, and the first worship service was held in 1885.

The first name of the church was the Second Colored Baptist Church of Montgomery. The church's name was changed to Dexter Avenue Baptist Church when the street it faced, Market Street, was renamed in honor of Andrew Dexter, founder of Montgomery.

Dexter has an early history of community service. Its basement was the site for the first registration of students for Alabama State University. Dexter's pastor, Reverend Martin Luther King, and members of the congregation were actively involved in civil rights activities. On September 1, 1973, the church's name was changed to pay tribute to Dr. Martin Luther King Jr., a

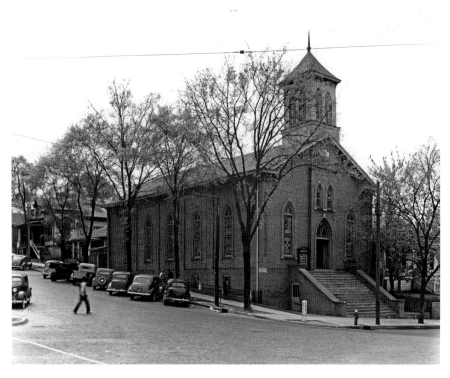

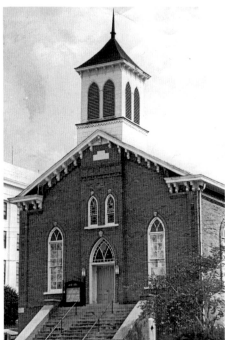

Above: The Dexter Avenue King Memorial Baptist Church in 1930; note the single front steps that were later replaced with stairs like the original entrance. *Alabama Department of Archives and History.*

Left: Dexter Avenue King Memorial Baptist Church in 1950 still had the single front steps. This photograph shows how the front of the church looked when Dr. Martin Luther King was pastor. *Alabama Department of Archives and History.*

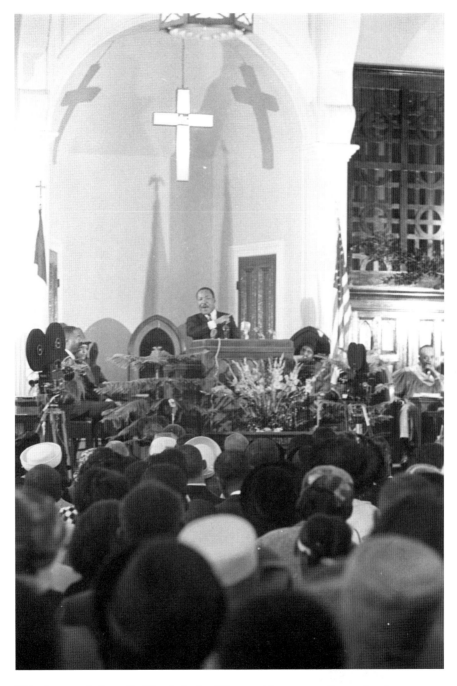

This photograph shows Dr. Martin Luther King speaking to an audience when he was pastor at Dexter Avenue Baptist Church (its name at the time) on December 10, 1967. *Alabama Department of Archives and History.*

former pastor and leader of passive resistance and nonviolent protest. The community refers to the church as "Dexter."

Prior to Dr. Martin Luther King Jr., Dr. Vernon Johns came to Dexter in 1947. His dramatic teachings aroused not only the Dexter family but also the citizens throughout Montgomery to the social transition that was taking place in the southern way of life. Among these constituents, he kindled a flame of freedom from economic, social and political oppression. Reverend Johns's steadfast resistance to the Jim Crow conditions in Montgomery paved the way for the success of Dr. King's heralded bus boycott.

In 1954, Dr. Martin Luther King became Dexter's twentieth pastor. The climate had been set by his predecessors for the social gospel Dr. King promoted. A disciple of Mohandas Gandhi, Dr. King preached a philosophy of nonviolent resistance. He raised the image of Dexter to a new peak in Christian work, enhancing the beacon light that shone as a symbol against oppression throughout the world.

Two weeks after his first sermon as designate-pastor, the Brown case was handed down, and school segregation was declared unconstitutional by the U.S. Supreme Court. It signaled a time of change. In Dr. King's first sermon as resident-pastor, he proposed a set of recommendations that inspired the founding of a series of clubs and organizations that would soon prove essential for the support of the bus boycott.

E.D. Nixon informed Dr. King at five o'clock in the morning on December 2, 1955, that Rosa Parks had been arrested for refusing to give up her seat on a city bus to a white man the previous evening. The first planning meeting was held in the lower unit of Dexter Avenue Baptist Church. The decision to stage a bus boycott was made in that meeting with about fifty community leaders and Reverend King. Those present formed the Montgomery Improvement Association and elected Reverend King as their leader. His first task was to address a large meeting at Holt Street Baptist Church. Many of Dexter's members attended this meeting and provided financial aid to help the bus boycott. The organizations formed at Dr. King's recommendation were integral to the success of the bus boycott. The women played a vital part. They prepared thousands of leaflets announcing the bus boycott and distributed them among the African American community. At first, the bus boycott was just for one day, a Monday, but it was so successful that the Montgomery Improvement Association decided to extend the boycott. For many days, the city and the bus company refused to negotiate—so the boycott continued.

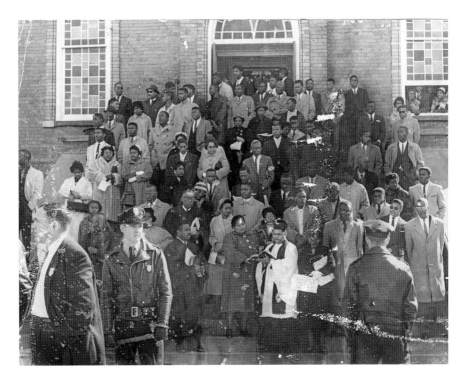

On March 6, 1960, members of Dexter Avenue King Memorial Baptist Church attempted to cross the street to the Alabama State Capitol for peaceful prayer. They were stopped by police officers. *Nelson Malden, Alabama Department of Archives and History.*

Since many African Americans in Montgomery depended on the bus to get them to work, the bus boycott put them at risk of losing their jobs. Many Dexter members organized a car pool. Some were arrested for that action. The Posey Parking Lot, owned by Eddie Posey, was located on South Hull Street. It was the only parking lot in Montgomery owned by an African American. The Posey parking lot served as one of the central points for the car pool from 1955 to 1956.

The bus boycott lasted 381 days. The ruling of the Supreme Court that bus segregation was unconstitutional was hailed as a victory for humanity. Those who participated were able to say, "My feet are tired, but my soul is rested."[11]

The Montgomery Bus Boycott propelled Dr. King and the civil rights movement into national and international consciousness. Dr. King left as pastor of Dexter Avenue Baptist Church in February 1960 because he felt that time did not allow him to fulfill the duties of both a pastor for Dexter Church and a leader in the civil rights movement.

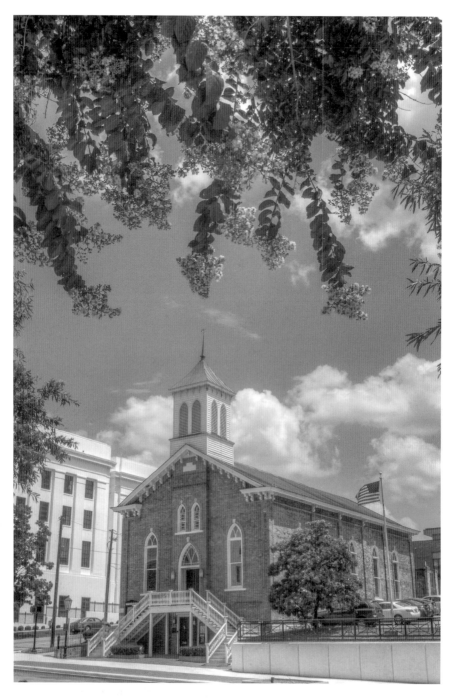

The beautiful Dexter Avenue King Memorial Baptist Church, shown from across the street in 2016. *Montgomery Convention and Visitors Bureau.*

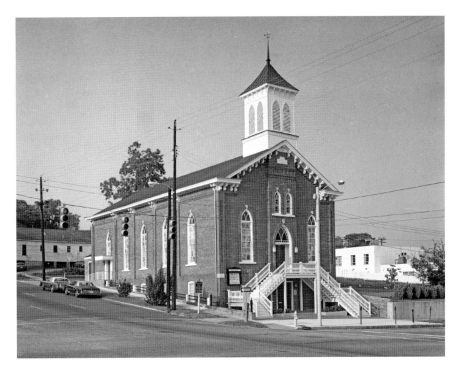

The Dexter Avenue King Memorial Baptist Church around 1980, after restoration but before the Southern Poverty Law Building was constructed behind it. *Alabama Department of Archives and History.*

Sunday, December 11, 2005, marked the 128th anniversary observance of the Dexter Avenue King Memorial Baptist Church. The theme was "Dexter Avenue King Memorial Baptist Church, a light in the community: Celebrating 128 years of service to God and the community and its role in the Montgomery Bus Boycott."[12] Guest speakers, music and recognition of special guests marked the celebration. The first music was the song "We've Come This Far by Faith."

The Dexter Avenue King Memorial Baptist Church continues its work to strengthen faith and hope. Some of the projects the church has completed include restoring the parsonage where the King family lived, known as the Dexter-King house, and making it open to the public; creating an interpretive center; building a new facility, the Legacy Center, behind the present sanctuary; and renovation of the church building.

Today, thousands of national and international tourists annually visit the Dexter Avenue King Memorial Baptist Church to be inspired and

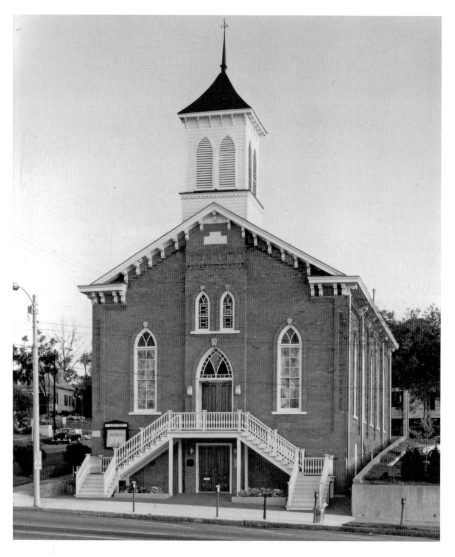

This 1990s photograph shows the side stairs on either side of the entrance restored to the original appearance of the front of Dexter Avenue King Memorial Baptist Church. *Landmarks Foundation.*

educated on the history of the church and its and Dr. King's role in the Montgomery Bus Boycott.

On June 3, 1974, the church was designated a National Historic Landmark by the National Park Service of the U.S. Department of the Interior in view of Dr. King's leadership in the civil rights movement. The city of Montgomery added the church to its list of designated historic sites

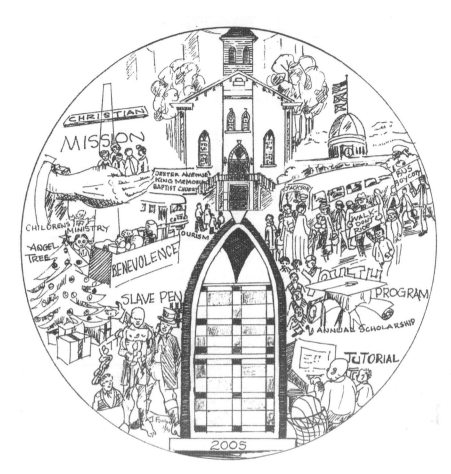

The program for the Dexter Avenue King Memorial Church's 128th anniversary celebration featured this medallion, created by artist John Feagin, which shows the many historical and service aspects of the church community. *Dexter Avenue King Memorial Baptist Church.*

on July 13, 1976. Landmarks Foundation of Montgomery on June 22, 1980, unveiled a historic marker on the site. The church parsonage was added to the National Register of Historic Places on March 10, 1982. Presently, the church is on the tentative list of UNESCO (United Nations Educational, Scientific and Cultural Organization) World Heritage Sites.

Tours of the church are available Tuesday through Saturday, every hour on the hour. Visitors may call for reservations or information at 334-261-3270 or 334-356-3494 or visit the website, dexterkingmemorial.org.

In addition to being an important historic church and community, Dexter Avenue King Memorial Baptist Church is an active spiritual

church community that continues to foster the growth of faith and hope. Current pastor Reverend Cromwell A. Handy invites visitors "to worship with us, to study with us, and to serve with us at the historic Dexter King Memorial Baptist Church."[13]

THE ALABAMA STATE CAPITOL

ELEANOR WILLIAMS CUNNINGHAM

Since 1850, the Alabama State Capitol has overlooked downtown Montgomery from its majestic hilltop setting. During this time, the great neoclassical portico has witnessed stirring historical events that have changed the face of the United States. In February 1861, Jefferson Davis stood beneath the tall Corinthian columns to be inaugurated president of the newly formed Confederate States of America. A little more than a century later, in the spring of 1965, the historic Selma–Montgomery civil rights march led by Dr. Martin Luther King Jr. ended at the capitol steps. Because of its place in history, the capitol was designated a National Historic Landmark by the secretary of the interior on December 19, 1960. Today, it is one of twenty-one state capitol buildings to have this distinguished title.

In the 1970s, a major push began to refurbish the capitol building. The first phase of this work—an exterior rehabilitation—was completed in 1981. Planning and research then began for an extensive interior refurbishment and restoration, plus construction of a new addition. This work was finished in 1992. Today, the capitol can best be referred to as a "working museum." It is a combination of historic spaces that are open to the public and working government offices.

Alabama has had several capital cities and capitol buildings. Alabama became a territory in 1817, and the territorial capital of St. Stephens was followed by the establishment of the town of Cahawba, at the confluence of the Cahaba and Alabama Rivers, in 1818. As Alabama moved toward

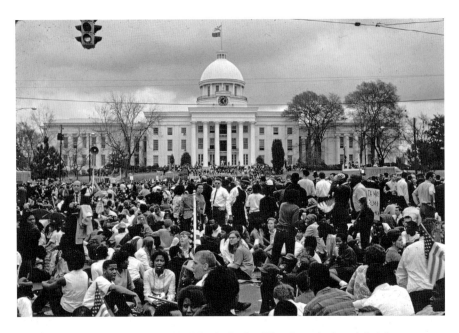

Selma–Montgomery marchers led by Martin Luther King Jr. and other civil rights movement leaders approached the Alabama State Capitol on March 25, 1965. *Alabama Department of Archives and History.*

statehood, Huntsville briefly served as capital and hosted the constitutional convention. By 1820, the seat of state government was at Cahawba, where it remained until 1826. In Cahawba, a capitol was built, but it, like the city itself, was abandoned when the capital was moved to Tuscaloosa. Cahawba became a ghost town, and all that remains of the capitol building is the top, architecturally called a "lantern," which crowns an old church in Lowndesboro, Alabama. The legislature then voted to move the capital to Tuscaloosa. An ambitious and grand capitol was built in Tuscaloosa. Though occupied in 1833, it was never finished. By 1844, a population, economic and political shift toward the center of the state made centrally located Montgomery the choice for a new capital city. The city of Montgomery, located in the geographical area known as the Black Belt, had become a wealthy and politically powerful town. To ensure that the legislature's decision went its way, the city of Montgomery promised to finance a capitol building. It was often said that the capitol should be on wheels, since it moved so often.

The new capitol building in Montgomery was situated on Goat Hill. The story is that Andrew Dexter, founding father of Montgomery, always believed Montgomery would someday be the state's capital, and to that end,

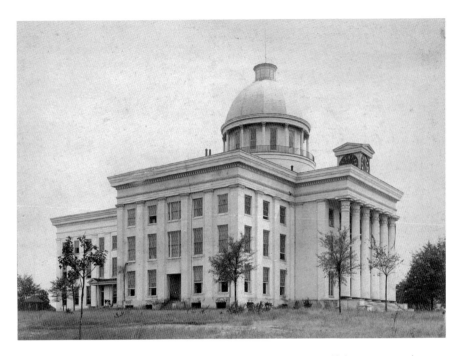

The northwest side of the Alabama State Capitol in Montgomery, Alabama, as seen in 1886. *Alabama Department of Archives and History.*

he donated the hill. However, during his lifetime, only his goats enjoyed the grassy hilltop. Dexter's dream came true, and his goats are also remembered. However, the official name of the capitol's location is Capitol Hill.

In 1846, Montgomery sponsored a design competition for the new capitol building. Stephen Decatur Button of Philadelphia won the competition and designed a Greek Revival structure with a domed central portion. However, this building was destroyed by fire in December 1849. The city did not offer to pay for the capitol building the second time. The city did, however, pay for the clock.

Barachias Holt, a native of Maine who moved to Montgomery about 1847, served as the construction supervisor for the rebuilding of the capitol. The new capitol featured a three-story portico in contrast to Button's two-story one. Button's dome was also lower than the current dome. The Corinthian capitals, based on the capitals of Athens's Tower of the Winds, were reused from the first capitol building. The capitol is brick, covered with stucco, scored to imitate a marble or stone finish.[14]

As Alabama and its government grew, so did the state capitol. By 1885, the Supreme Court needed more space, so an east wing was added to house

a new law library and offices. In 1906, the south wing was added. This wing was designed by noted Alabama architect Frank Lockwood, in collaboration with Charles F. McKim. Lockwood also designed the north wing, which was

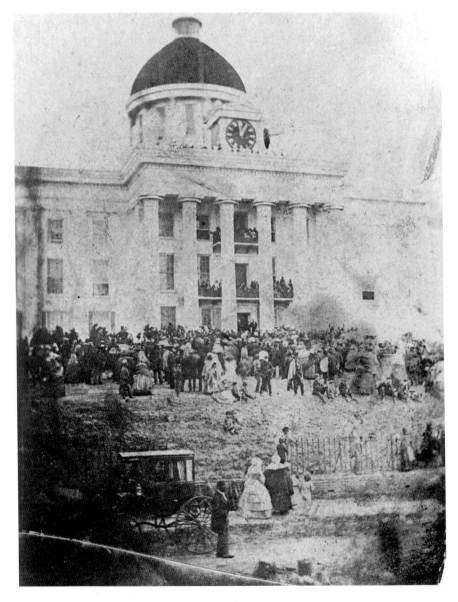

This very early image shows Jefferson Davis being inaugurated as the president of the Confederate States of America on the steps of the Alabama State Capitol on February 18, 1861. *Alabama Department of Archives and History.*

added in 1911. In the 1950s, Governor James E. "Big Jim" Folsom replaced the rather narrow front steps installed in the 1880s with the present wide Alabama marble front steps. The most recent addition to the capitol was the east wing expansion, completed in 1992. This addition houses an auditorium and the Goat Hill Museum Store.

The interior of the current capitol features some notable elements and has also undergone renovations and redecorations. Horace King, who was a freed slave brought to Alabama in 1832, built the soaring twin staircases in the lobby. An expert carpenter noted for his covered bridges, he also executed other carpentry work throughout the building. The Alabama legislature met at the state capitol until 1985. At that time, the capitol closed for interior restoration work, and the legislature moved to another building on Union Street. The Senate Chamber in the capitol is restored to its 1861 appearance, as it is the room in which the delegates from the seceding states voted to form the Confederate States of America. The original House Chamber, Supreme Court Chamber, Governor's Suite and Secretary of State's Suite have been restored to their 1870s–1880s appearances. The House Chamber is still used for state functions, such as the State of the State address.

One of the focal points of the capitol is the rotunda, which serves as the entrance to the legislative chambers. During the early years when the legislature was in session, local food vendors were allowed to set up in the rotunda and sell their wares: oranges, apples and even hams! Liquor was also allowed, although the legislature finally banned this practice altogether. Visitors during this time would have seen an extremely plain space with none of the plaster ornamentation now in place. A railed light well was most likely in the middle of the rotunda to provide natural light to the area below, on the first floor. The wooden floor was probably covered with carpeting or oilcloth (an early version of linoleum). A few years after the Civil War, the appearance of the rotunda was improved when the dome area was decoratively painted by Montgomery artists Peter Schmidt and Frank O'Brien.

In 1906–7, at the same time the south wing was constructed, the rotunda underwent extensive renovation. The walls were replastered, and ornate cornices and moldings were added. The wooden floors were replaced by white Georgia marble because Alabama marble was considered too soft and a Georgia company was the lowest bidder. A stained-glass skylight was installed at the top of the dome, and electric fixtures were added around the rotunda. Mahogany vestibules were placed in front of the doors to the House and Senate Chambers.

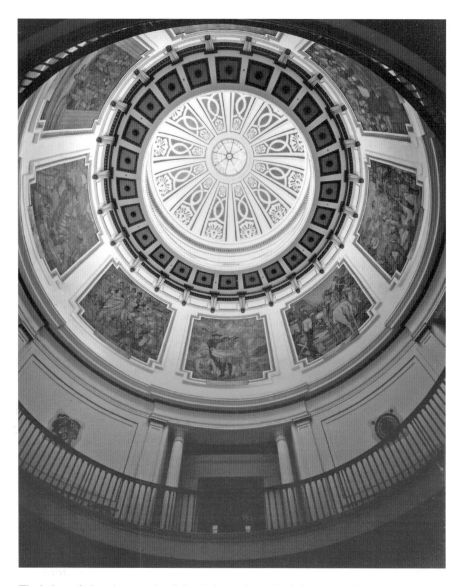

The balcony below the rotunda of the Alabama State Capitol opens to the chambers of the house of representatives and the senate. The rotunda features murals by Roderick MacKenzie. *Landmarks Foundation.*

Another major redecoration occurred between 1927 and 1930 when the eight large murals depicting fanciful scenes from Alabama history were painted and installed. Roderick D. MacKenzie, a London-born artist of Scottish descent who grew up in an orphanage in Mobile, painted

the murals in his studio, sometimes using live models. The large canvas paintings were then installed in the rotunda. At the balcony level of the rotunda, the walls are decorated with coats of arms and elaborate decorative plasterwork constructed by the MacKenzie and Colby Decorating Company of Birmingham. The coats of arms, in bronze leaf and a bronze wash, represent governments (besides the United States) that have ruled over the Alabama territory: France, England, Spain and the Confederacy.

Shortly before World War II, MacKenzie's scheme was altered, and the rotunda was painted a creamy white. The rotunda has now been restored to the color scheme developed by MacKenzie when he first installed the murals. The restoration is based on detailed analysis of original paints beneath more recent paint layers, supplemented by extensive documentary research.

When the present capitol building was completed in 1851, there was not a comprehensive plan to landscape the grounds around the building. In 1889 Frederick Law Olmstead, the nationally prominent landscape architect, prepared a landscape design for the grounds. However, his plans were never implemented due to a lack of funds. The first attempt at improving the appearance of the building's grounds did not occur until 1868, when "native forest evergreens" were planted. Many more trees were added in the ensuing years, including several elms. The grounds surrounding the building were "disfigured by small and not beautiful structures,"[15] which included a well house, a cistern house, a coal house, "summer" houses and privies. Improvements came slowly, with the first major renovation being the replacement of the wooden fence with a brick, stone and wrought-iron fence in 1885.

The monuments on the capitol grounds are dedicated to people or events important to the development of Alabama as a state.

The Confederate Memorial Monument, on the north lawn, is the largest and oldest of the capitol ground monuments. Fundraising for the Confederate Monument began in the summer of 1879; however, it took twelve years to complete, with a cost of $46,000. The cornerstone was laid on Confederate Memorial Day in 1886 by Jefferson Davis, the former president of the Confederacy. The monument is thirty-five feet square and eighty-two feet tall and made predominately of limestone from Colbert County, Alabama. The four granite figures around the base represent the four primary branches of the Confederate armed forces: infantry soldiers, who marched and carried muskets; cavalry soldiers, who rode horses and fought with revolvers, carbines and sabers; artillery soldiers, who manned cannons; and, finally, navy sailors, who operated in sailing ships, steamers,

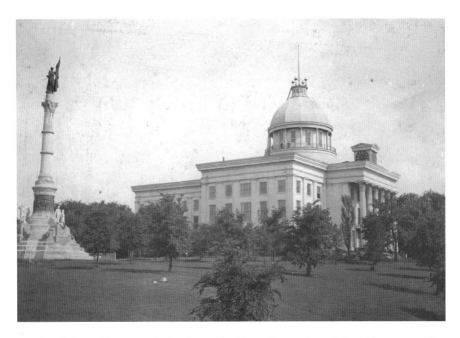

The Confederate Monument is clearly seen in this northwest view of the Alabama capitol. *Alabama Department of Archives and History.*

ironclads and submarines. The initials below each engraving belong to the author of that inscription. The bronze bas-relief is representative of any southern battlefield, and the bronze figure atop the seventy-foot shaft is symbolic of southern womanhood and patriotism.[16]

The U.S. flagpole on the south lawn was dedicated in April 1918 as a World War I memorial. The Avenue of Flags was dedicated in May 1969 during the celebration of Alabama's 150th birthday. The flags stand in a semicircle between the Ionic portico of the capitol's south wing and Washington Avenue. Each of the fifty states is represented by its individual state flag, and at the base of each flagpole, that state's name is carved into a sample of the state rock. In addition to the twenty-three monuments and markers now on the grounds, there were, at one time, cannon from Fort Barrancas in Pensacola, Florida, and a flagpole from a Spanish ship destroyed in Manila Bay during the Spanish-American War.

Statues also grace the capitol grounds. Confederate president Jefferson Davis stands in front of the capitol. Under shady trees or open spaces stand images to honor the work of doctors and surgeons in addition to the sacrifices of assassinated politicians and fallen police officers. The monuments and memorials surrounding the building make a tour of the grounds an interesting lesson in Alabama history.

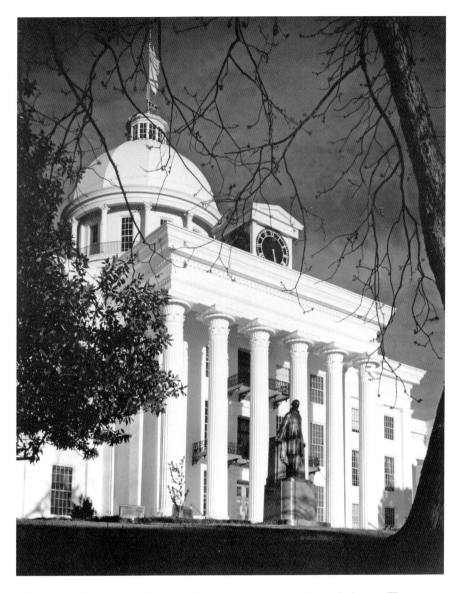

Jefferson Davis was sworn in as Confederate president on the capitol steps. The Confederate Battle Flag, raised in 1963, was lowered in 1992. *Landmarks Foundation.*

The capitol remains an important building and symbol of the Civil War and the struggle for civil rights. A star marks the spot where Jefferson Davis took the oath of office as president of the Confederacy. A marble stele marks the day and place the Selma–Montgomery marchers arrived

at the capitol steps. Those steps continue to be a place where various groups gather to publically give voice to contemporary issues. Come visit the Alabama State Capitol.

ALABAMA DEPARTMENT OF ARCHIVES AND HISTORY AND MUSEUM OF ALABAMA

GEORGIA ANN CONNER HUDSON

For well over a century, the Alabama Department of Archives and History has been the home of Alabama history, collecting, preserving and sharing the artifacts and records that tell the story of the state and its people. Located atop Goat Hill, directly across the street from the state capitol, the stunning, Greek Revival–style archives building contains award-winning, Smithsonian-quality museum exhibits; a state-of-the-art research facility; and myriad activities and programs for all ages. The Alabama Department of Archives and History serves the state of Alabama as the official government records repository, as a special collections library and as Alabama's history museum. Opened in 2011 and 2014, the Museum of Alabama's completely redesigned museum exhibits have made the archives a new destination for Alabamians and visitors from across the nation and the globe. A visit to the Alabama Department of Archives and History immerses guests in the story of Alabama, from Native American history to the Civil War, the civil rights movement and beyond.

In 1901, Alabama created the first state-funded archival and historical agency in the United States. The movement to create the Alabama Department of Archives and History represented a convergence of cultural interests. The progressive movement, then spreading across the United States, reflected an interest in improved education. With the growth of schools, an increase in the number of professional historians and the professionalization of historical training and education came an increasing need for a facility

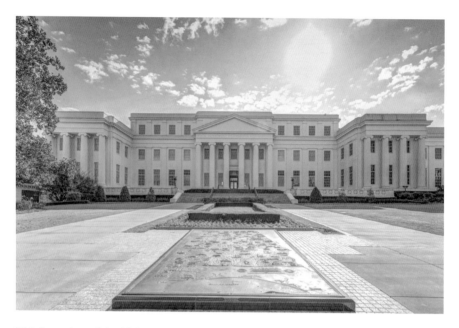

This front view of the Alabama Department of Archives and History faces the south side of the Alabama State Capitol. *Alabama Department of Archives and History.*

where Alabama's historical materials could be studied and accessed by the public. There was also a growing interest in preserving the materials that document the past. By the turn of the twentieth century, Alabama was more than eighty years old, yet there was no formal system in place for preserving its historical records and artifacts.

Thomas McAdory Owen, an attorney from Jefferson County, Alabama, advocated for the establishment of the archives and served as its first director. In 1893, he married Marie Bankhead, daughter of U.S. senator John Hollis Bankhead. Marie shared Tom's interest in history, and her family's political connections throughout the state helped advance his idea of creating a state archives. On February 27, 1901, Governor William J. Samford signed into law the bill establishing the Alabama Department of Archives and History. Just a few days later, on March 2, Thomas Owen was named director.

The archives' first office space was in the Senate cloak room at the state capitol. Almost immediately, Thomas Owen began acquiring significant records and artifacts that documented Alabama's past. He envisioned the agency as a cultural institution with a broad mission, serving Alabama's citizenry not only as the state archives but also as the state history museum. He persuaded the legislature to allow use of the Alabama State Senate

The museum and archival collections of the Alabama Department of Archives and History were housed in the Alabama State Capitol before the archives building was constructed. *Alabama Department of Archives and History.*

Chamber as a public display space when the legislature was not in session. When the capitol was expanded in 1906–7, the archives gained new office and collections space in the new south wing, a room still referred to today as the "Old Archives Room."

During Thomas Owen's tenure, the Alabama Department of Archives and History considerably increased its holdings to include significant Civil War–era collections, nineteenth- and early twentieth-century personal papers, nineteenth-century portraits and Civil War flags. The passage of a law in 1915 stipulating that public officials transfer noncurrent records to the archives assisted Thomas Owen in collecting Alabama state records from the previous century. With a growing collection of historical materials, Owen envisioned construction of a permanent building to house the archives. In 1919, the legislature created a State Memorial Commission to plan for a state building that would memorialize those killed during World War I and also house the archives. The commission began purchasing land across the street from the Alabama State Capitol. Thomas Owen died in 1920 and never saw his dream of an adequate home for the Alabama Department of Archives and History become a reality.

After Thomas Owen's death, the Alabama Department of Archives and History Board of Trustees chose his widow, Marie Bankhead Owen, to succeed him as director. She was the second woman to head a state agency in Alabama and served as director of the archives for the next thirty-five years. One of Marie's most lasting contributions was her success in securing New Deal funding in the late 1930s to construct the War Memorial Building,

Thomas McAdory, founding director of the Alabama Department of Archives and History, sits in his office. *Alabama Department of Archives and History.*

which would also serve as the archives' permanent home. The building opened in 1940 to national acclaim.

The original construction included only the central portion of the current building. Expansions to the east in 1974 and the west in 2005 completed the architect's original intent for an H-shaped building. The walls of the central building are lined with richly veined marble quarried in Sylacauga, Alabama. The interior is defined by ornate architectural elements, Art Deco light fixtures and intricate carved reliefs representing various themes of Alabama's history.

The Alabama Department of Archives and History continued to advance its mission under the leadership of successive directors throughout the mid- and late 1900s. By the dawn of the twenty-first century, many of the museum's exhibits had become outdated, and planning began for a complete redesign of the Museum of Alabama. Thanks to the foresight of Thomas Owen and succeeding directors, the archives' collections were extensive. However, an effective interpretation of the materials required a historical context and style of presentation that was lacking.

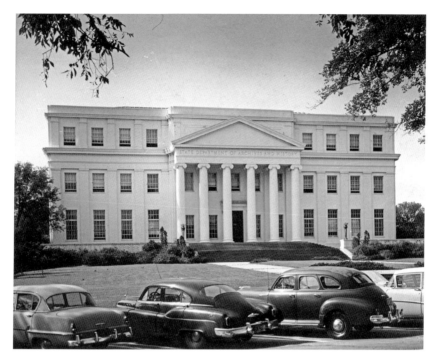

This view from around 1940 shows the Alabama Department of Archives and History before the wings were constructed. *Alabama Department of Archives and History.*

The south lobby of the Alabama Department of Archives and History features busts of prominent Alabamians. *Alabama Department of Archives and History.*

The main lobby of the Alabama Department of Archives and History features marble floors and gilt ceilings. *Alabama Department of Archives and History.*

After nearly a decade of research, design and fundraising, the first two permanent exhibitions of the newly designed Museum of Alabama opened in 2011. *The Land of Alabama* introduces visitors to Alabama's diverse geology and the natural resources that helped shape the state's history. *The First Alabamians* tells the compelling story of fourteen thousand years of Native American history through original murals, a diorama and the museum's impressive artifact collections.

Almost immediately after the opening of these galleries, work began on what is now the centerpiece of the Museum of Alabama, the *Alabama Voices* exhibit. This Smithsonian-quality exhibit covers the dramatic unfolding of Alabama history from the dawn of the 1700s to the beginning of the twenty-first century. More than eight hundred artifacts, hundreds of images and documents and twenty-two audiovisual programs tell the story of struggles over the land, the rise of a cotton economy, the Civil War, industrialization, world wars, civil rights, the race to the moon and more. Voices taken from diaries, letters, speeches, songs and other sources convey the experiences of Alabamians who lived through and shaped the history of these periods. Occupying nearly eleven thousand square feet, *Alabama Voices* opened to wide acclaim in 2014 as an important new cultural and educational resource for the state.

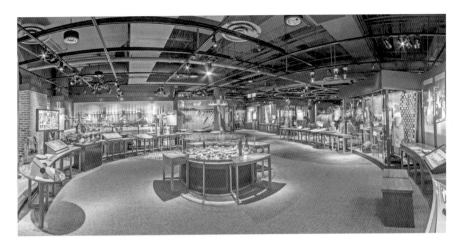

The *Alabama Voices* exhibit provides an innovative learning experience. *Alabama Department of Archives and History.*

The new state-of-the-art *Alabama Voices* exhibit tells of the early days of Alabama. The exhibit is housed at the Alabama Department of Archives and History. *Alabama Department of Archives and History.*

Additional galleries include Alabama Treasures, an exhibit space that has been restored to its original appearance from when the building first opened in 1940. The space houses temporary and traveling exhibits utilizing some

of the museum's original display cases. During the year, various temporary exhibits are on display throughout the building featuring textiles, original records, artifacts and other materials.

The Hands-On Gallery is a popular destination for children and families. Featuring crafts, touch-its and educational activities based on different themes of Alabama history, this gallery helps young visitors connect with the past while building new memories with their families. The Hands-On Gallery also houses Grandma's Attic, where children can dress up in period costume and play with vintage toys and games.

In addition to the Museum of Alabama, the EBSCO Research Room allows visitors to delve deeper into Alabama's past and their own family histories. Offering state-of-the-art research tools and access to original records from the archives' collection, the EBSCO Research Room is a must-visit destination for anyone interested in genealogical and historical research. An expert staff is on hand to provide guidance. Free access is provided to many online resources, such as Ancestry.com, through the Research Room's computers.

Throughout the year, the Alabama Department of Archives and History offers numerous public programs, such as lunchtime lectures, symposiums, workshops, film screenings and family activities. The building has become a vibrant part of Montgomery's cultural landscape, attracting visitors from all walks of life.

While the Alabama Department of Archives and History serves the entire state, its collections and museum exhibits also document the story of the city of Montgomery and the pivotal role that it played in both the Civil War and the civil rights movement. Located just steps away from where many of these transformative events occurred, Alabama's Department of Archives and History's rich Civil War and civil rights collections place these turning points into the larger context of Alabama and national history.

Now in its second century of service to the state of Alabama, the Alabama Department of Archives and History has become the thriving cultural institution that Thomas Owen envisioned in 1901. Today, the archives are committed more than ever to the core mission of collecting, preserving and sharing Alabama's history.

The Alabama Department of Archives and History and the Museum of Alabama are open Monday through Saturday, from 8:30 a.m. to 4:30 p.m. The EBSCO Research Room is open Tuesday through Friday and the second Saturday of each month from 8:30 a.m. to 4:30 p.m. Admission is always free. Visit www.archives.alabama.gov for the latest information on exhibits and upcoming events.

FIRST WHITE HOUSE OF THE CONFEDERACY

ANNE TIDMORE AND CAMERON FREEMAN NAPIER

The First White House of the Confederacy, a house museum located at 644 Washington Avenue in Montgomery, was the executive residence of President Jefferson Davis and his family while the capital of the Confederate States of America was in Montgomery.

The inevitable evolution of differences between the North and South over slavery, states' rights, nullification, taxation and tariffs, immigrants, migration patterns and western movements came to a head with Abraham Lincoln's election as the sixteenth president of the United States in November 1860. This election caused South Carolina to secede from the Union in December, followed by Mississippi, Florida, Alabama, Georgia, Louisiana and Texas. On February 4, 1861, the seceded states met in Alabama's state capitol in Montgomery to form the Confederate States of America.

On February 8, 1861, the Provisional Confederate Congress convened in the Senate Chamber for the purpose of electing a president. Jefferson Davis, distinguished military hero, statesman, patriot and Mississippi planter, was chosen unanimously. Davis received the news by telegram at Brierfield, his plantation at Davis Bend on the Mississippi River near Vicksburg, on February 10. Accepting reluctantly, he journeyed to Montgomery by riverboat and train, arriving on the sixteenth. Jefferson Davis was inaugurated provisional president of the Confederate States of America on the front portico of the capitol on February 18, 1861, at 1:00 p.m.

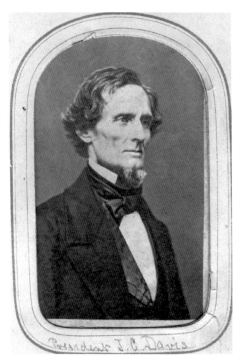

Left: Jefferson Davis was elected president of the Confederate States of America in 1861 in Montgomery, Alabama. *Alabama Department of Archives and History.*

Below: The First White House of the Confederacy is a strong example of Italianate architecture. *Landmarks Foundation.*

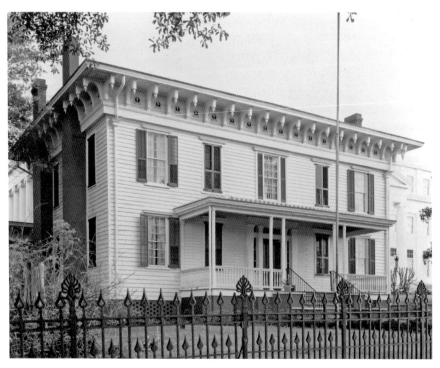

In creating their new nation, the Confederates essentially duplicated the institutions of the old Union. They fervently believed that it was they who, by creating a new nation, were perpetuating the ideals of their revolutionary forebears. They set up all departments necessary for the functioning of government. Therefore, they decided to also provide the chief executive with a residence—that is to say, a "White House."

Colonel Edmund S. Harrison of nearby Prattville, Alabama, had recently bought a newly renovated house from Joseph Winter for use as a town house. He offered to rent it completely furnished and staffed for $5,000 a year. And so on February 21, 1861, the Provisional Confederate Congress authorized the leasing of an Executive Mansion.

The house had been built between 1832 and 1835 by William Sayre (an ancestor of Zelda Sayre, who married author F. Scott Fitzgerald). There were a series of owners, but Colonel Winter, who purchased it in 1855, renovated the two-story Federal frame house to the then more fashionable Italianate style. Suitable as a gentleman's residence, the home was situated close to the river, on what is now the southwest corner of Lee and Bibb Streets.

Varina Davis, President Jefferson Davis's wife, arrived in Montgomery by riverboat to cheering crowds on the afternoon of March 4, 1861, shortly after President John Tyler's granddaughter Letitia Tyler raised the first national flag of the Confederacy, the Stars and Bars, on the Alabama State Capitol grounds. From their temporary suite at the Exchange Hotel, Mrs. Davis began supervising the redecoration of the new residence. During the first part of April, she returned to Brierfield to retrieve some "silver, china, linens, lamps and a few favorite books."[17] She then came back to Montgomery on April 14 and moved with the president into the White House of the Confederacy with their three small children.

Although President Davis maintained offices at the Government Building a block away, he also conducted the urgent business of forming a new government at the nearby Exchange Hotel and made serious decisions in his study at home. Each evening, however, promised a glittering social event. The White House of the Confederacy attracted the best minds of the day and the most prominent and powerful of the South's political and social leaders.

During the spring of 1861, the White House of the Confederacy in Montgomery sparkled as Mrs. Davis, eighteen years her husband's junior, gave lively dinners, levees and teas and held salons. Contemporary writers described "stately dining, and brilliant receptions, held after the Washington custom" and noted those attending as "the most brilliant, most gallant and most honored of the South."[18]

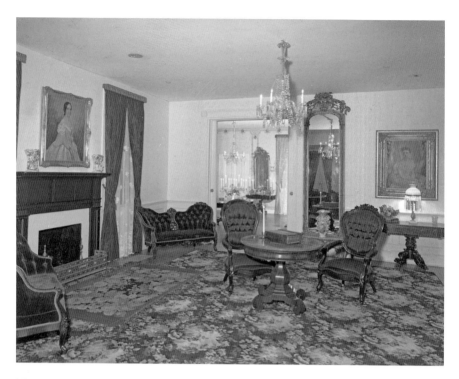

The parlor of the First White House of the Confederacy is decorated with antebellum furniture. *Alabama Department of Archives and History.*

In a telegram on April 10, 1861, Brigadier General P.G.T. Beauregard was given discretionary authority by the Confederate States of America War Department to "demand evacuation of Fort Sumter, or reduce it." Firing began, and Lincoln subsequently called for seventy-five thousand volunteers to "suppress the rebellion." This resulted in Virginia, Tennessee, Arkansas and North Carolina joining the Confederacy. On May 20, 1861, the Provisional Confederate Congress passed a resolution to move the Confederate capital to Richmond, Virginia, and to reconvene there on July 20.

By May 29, the president had arrived in Richmond. Mrs. Davis remained in Montgomery to supervise the packing at the First White House. After the middle of June, she was holding receptions at the Spotswood Hotel in Richmond while waiting to move into the old Brockenbrough House. The Brockenbrough House would remain the White House of the Confederacy for the duration of the war that would cost 620,000 American lives.

The First White House of the Confederacy survived the Civil War. Ownership of the "Jeff Davis House," as it was called, passed through several hands. In 1873, the owner of the house, Sallie Render, lived in LaGrange, Georgia; she rented it to various tenants.

In 1897, the first state convention of the newly formed United Daughters of the Confederacy (UDC) proposed to preserve the First White House. A committee, with Carrie Phelan Beale as chairman, worked on the project. Because Carrie Beale and Varina Davis were longtime friends, Varina Davis agreed to give President Davis's bedroom furniture and other items from Beauvoir, the Mississippi home to which the Davises had retired, to the White House Committee and the State of Alabama. These "relics" were placed on display in a room at the state capitol until the house was purchased.

Unfortunately, the arduous and frustrating task of purchasing the house would take twenty years. Foreseeing the UDC's abandonment of the project (but still working with the organization's committee), twenty-seven women dedicated to the project founded the White House Association of Alabama on July 1, 1900. Patterned after the Mount Vernon Ladies' Association of the Union, which had been formed in 1853 to save George Washington's home, the White House Association of Alabama was chartered on February 5, 1901, by an act of the Alabama state legislature for the sole purpose of preserving the First White House of the Confederacy.

All the Davis furniture and family belongings that had been in joint custody of the UDC's White House Committee and the State of Alabama were signed over by Varina Davis on March 27, 1902, to the White House Association of Alabama for perpetual keeping. Also, in 1902, all UDC monies raised toward the project were transferred to the White House Association of Alabama. In 1903, the UDC dropped the project entirely.

The Davis House remained entailed property. The Render family was unwilling to sell the land on which the house stood, because of rising land prices in what was called the "Cavalier District." The White House Association of Alabama was unable to raise the money to move the house. With litigation complicated, demolition imminent and circumstances intolerable, a sympathetic governor came to the rescue. In 1919, Governor Thomas E. Kilby signed into law a bill appropriating $25,000 for the purchase and relocation of the White House of the Confederacy. By this time, the old home was a boardinghouse for trainmen and was in sad condition. The White House Association of Alabama purchased the house for $800, with $5 down. It purchased a lot in the shadow of the capitol. A Montgomery city engineer, after photographing and documenting it inside

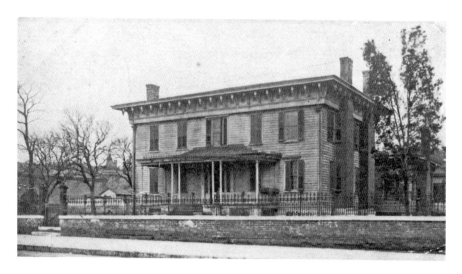

The First White House of the Confederacy was originally downtown at the corner of Bibb and Lee Streets. *Alabama Department of Archives and History.*

and out, skillfully dismantled the house by thirds, numbered the lumber, moved it the ten blocks to its new site and reassembled it.

Judging from newspaper accounts, the dedication ceremony at the opening of the restored First White House of the Confederacy on June 3, 1921, was one of the most thoroughly relished and enjoyable occasions in Alabama history. Hundreds of people participated in an elaborate parade that ended on the south lawn of the capitol grounds, where the ceremony took place. The White House Association gave the house, fully refurbished, to the people of the state of Alabama. The governor accepted it, and thousands participated in a banquet that night with a reception following.

Legislation passed in 1923 and amended since provides that the White House Association of Alabama manages the First White House of the Confederacy. The State of Alabama maintains the house and grounds. The association owns the things in the house, and its members are the "keepers of the relics" and the arbiters of taste in maintaining the interior and in all matters concerning the house.

Upon the death of Varina Davis on October 16, 1906, in New York City, her position as queen regent of the White House Association was left unfilled. She remains queen regent in perpetuity. Varina Davis's longtime family friend Carrie Phelan Beale was the first regent of the White House Association, from 1900 to 1906, followed by Belle Allen Ross from 1906 to 1919. Marilou Armstrong Cory held that post from 1919 to 1951, Ruth

McMillan Rowell served from 1951 to 1980 and Cameron Freeman Napier was regent from 1980 to 2009, at which time she became honorary regent for life. Anne Henry Tidmore was regent from 2009 to 2015, and Siebels Lanier Marshall was installed as regent in 2015 and is currently serving.

The First White House has undergone three major restorations since 1921. The first was in 1976, when steel beams were put under the floors to support the house; the second, in 1996–97, was a lead paint abatement project; and the third, in 2007–8, replaced the heating and air-conditioning systems. In recent months the entire outside and inside of the house have been painted; ceilings repaired or replaced; the grounds landscaped; and the driveway, sidewalk and walls pressure washed.

Today, the White House Association of Alabama is composed of about sixty-one ladies from all over the state who are related to the charter members or are otherwise connected with the house. Each member is responsible to help keep up one of the rooms. Members meet twice a year. In addition, members are expected to attend the annual Jefferson Davis

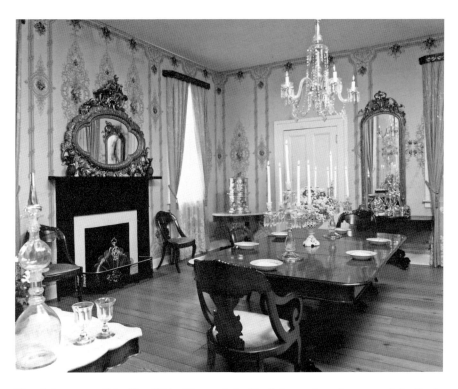

The dining room of the First White House of the Confederacy, featuring some of the Davis family possessions, looks ready for guests. *Landmarks Foundation.*

birthday commemoration on June 3 and the Robert E. Lee birthday commemoration on January 19.

The White House Association of Alabama is the oldest preservation organization in the state of Alabama and one of the oldest in the United States dedicated solely to the preservation of a house museum. It is a 501(c)(3) organization. The association works in partnership with the State of Alabama, always striving for excellence and integrity in maintaining the First White House of the Confederacy as it appeared in the spring of southern independence in 1861. The furnishings are either of the 1850s and 1860s periods, original to the house or belonged to the Davis family. The house has been listed in the National Register of Historic Places since 1974.

Located at the corner of Union Street and Washington Avenue, across from the south side of the Alabama State Capitol and next door to the Alabama Department of Archives and History, the house and its contents, as a teaching tool, speak eloquently of its past and of the intelligence and perseverance of the women who saved it. The White House of the

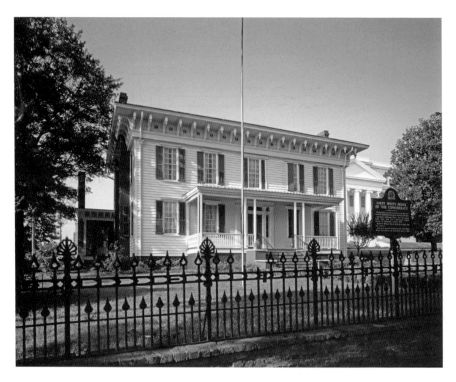

The First White House of the Confederacy currently stands at 644 Washington Avenue. *Alabama Department of Archives and History.*

Confederacy tells three stories: what happened in the spring of 1861 when a government was formed from few resources except cotton and courage; the story of Jefferson Davis, American patriot, war hero and the only president of the Confederate States of America; and the fascinating story of the preservation of the house.

The First White House of the Confederacy is free of charge and open to the public, Monday–Friday from 8:00 a.m. to 4:30 p.m. and Saturdays, 9:00 a.m. to 4:00 p.m. It is closed on most federal and state holidays and on Sundays. The downstairs is handicap accessible. We hope you will join the over twenty-six thousand visitors who come each year, and visit the First White House of the Confederacy at your earliest opportunity.

CIVIL RIGHTS MEMORIAL AND CENTER

BOOTH GUNTER

On November 5, 1989, six thousand people gathered in downtown Montgomery, Alabama, to hear civil rights luminaries, including Rosa Parks and Julian Bond, reflect on the sacrifices of those who were killed during the movement to overturn Jim Crow segregation and secure equal rights for African Americans.

Those present had come together to dedicate a new monument—the Civil Rights Memorial—to honor the martyrs who gave their lives for the cause of equality. Parks, whose act of defiance sparked the Montgomery Bus Boycott and lit a flame that ultimately consumed Jim Crow, reminded the audience that the struggle for justice was not over, even though the Civil Rights Act had banned racial discrimination in public accommodations twenty-five years earlier. Parks said, "It never ends. But we are living in hope that the future, as we gather for peace, justice, goodwill, and the priceless life of all, that we will not have to mourn the dead, but rejoice in the fact that we, as a nation of peace-loving people, will overcome any obstacle against us."[19]

Today, the Civil Rights Memorial, built and maintained by the Southern Poverty Law Center (SPLC), remains both a solemn tribute to sacrificed lives and a powerful tool to teach children and adults about the movement and today's human rights challenges.

An estimated fifty thousand people visit the Civil Rights Memorial each year. Many of them also tour the adjacent Civil Rights Memorial Center, an interpretive facility that helps visitors deepen their understanding of

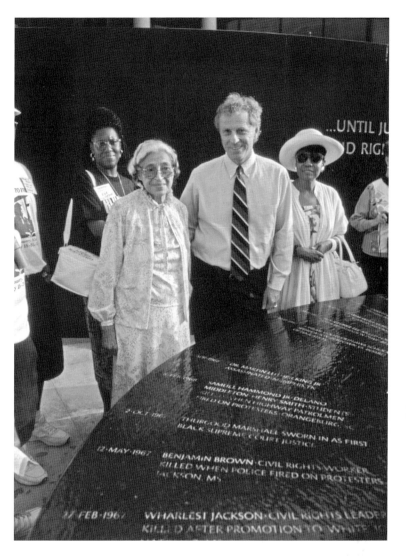

Rosa Parks and Morris Dees stand beside the Civil Rights Memorial on July 19, 1995. *Alabama Department of Archives and History.*

the movement and learn more about the forty martyrs whose names are inscribed on the black granite memorial. The center's state-of-the-art exhibits and original short film, *Faces in the Water*, encourage thoughtful reflection on the power of individual activism. As they are leaving, visitors to the Civil Rights Memorial Center can pledge to work for justice, equality and human rights in their own lives by adding their names to the Wall of Tolerance, a digital cascade of multicolored names falling, like the water

on the memorial outside, down the face of a massive, curved black wall. Surrounded by historic sites, the Civil Rights Memorial stands in an open plaza accessible to visitors twenty-four hours a day, seven days a week. It stands just around the corner from the Dexter Avenue King Memorial Baptist Church, where Dr. Martin Luther King Jr. served as pastor during the 1955–56 Montgomery Bus Boycott, and about two blocks from the Alabama capitol steps, where the Selma–Montgomery voting rights march ended in 1965. Lecia Brooks, director of the Civil Rights Memorial Center, explains, "The Civil Rights Memorial serves as a reminder that everyday people possess the power to bring powerful social change through nonviolent means. Each name inscribed in the Memorial provides a lesson of courage, commitment and sacrifice."[20]

The memorial was the brainchild of Morris Dees, the Alabama native and civil rights lawyer who founded the Southern Poverty Law Center. In 1987, he was speaking at the annual convention of the Alabama NAACP, where he was being honored for the SPLC's court victory over the United Klans of America for the murder of a black teenager in Mobile, Alabama.

During the speech, Dees recited the names of civil rights activists and others killed during the movement. Afterward, he was asked by young people about some of those he had named—people like Emmett Till and Viola Liuzzo. Dees was troubled that the young people knew so little about such an important—and recent—part of the nation's history. He decided that the SPLC should build a monument to the martyrs of the movement so that their sacrifices would never be forgotten.

The SPLC commissioned Maya Lin, creator of the Vietnam Veterans Memorial in Washington, D.C., to design the monument. Lin spent months researching the movement and was shocked that so much violence had occurred. Lin wrote in her book, *Boundaries*: "[B]ut I was even more disturbed that the information I was learning about our history—events that were going on while I was growing up—was never taught to me in school."[21]

While designing the memorial, she drew inspiration from a quotation from Dr. King's "I Have a Dream" speech in which he paraphrased Amos 5:24: "We are not satisfied and we will not be satisfied until justice rolls down like water and righteousness like a mighty stream." Lin stated, "Immediately I knew that the memorial would be about water and that these words would connect the past with the future."[22]

As Lin worked on the design, SPLC researchers began combing through historical records about violent deaths that occurred during the movement

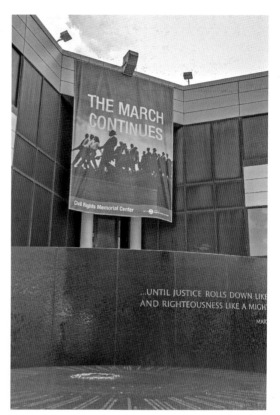

Right: The Civil Rights Memorial and Center is across the street from the Southern Poverty Law Center. *Montgomery Convention and Visitors Bureau.*

Below: This photograph shows Maya Lin working with members of the Southern Poverty Law Center on the Civil Rights Memorial. *Southern Poverty Law Center.*

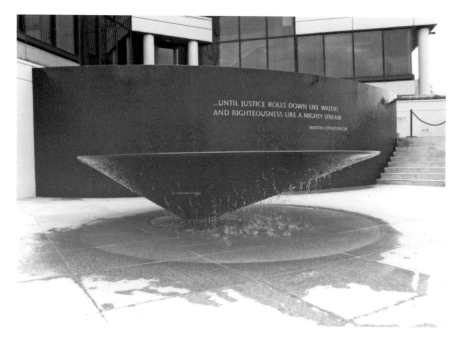

The Civil Rights Memorial uses water to create an emotional experience. *Alabama Department of Archives and History.*

from May 17, 1954, the day the U.S. Supreme Court outlawed school segregation, until April 4, 1968, when Dr. King was assassinated.

The research yielded forty names, though there were countless other suspicious deaths. Those selected ranged in age from eleven to sixty-six. They were students, farmers, ministers, truck drivers, a homemaker, a deputy sheriff and a Nobel laureate. Thirty-two were black. Eight were white. "Each name is a history lesson, and we are saying, don't just think of the deaths, but think of a movement of ordinary people who just got tired of injustice," Morris Dees told the *New York Times* in 1989.[23]

Some of the martyrs, such as Dr. King and NAACP field secretary Medgar Evers, were assassinated because of their leadership roles or personal activism. Others, like the Birmingham girls Addie Mae Collins, Denise McNair, Carole Robertson and Cynthia Wesley, were victims of terrorism committed by white supremacists intent on instilling fear in civil rights activists and the black community. Still others, like Emmett Till, were those whose deaths stirred the souls of millions by demonstrating the brutality and injustice faced by African Americans in the Deep South. Together, their deaths helped propel a great movement.

Many of the names—such as James Chaney, Andrew Goodman and Michael Schwerner, the civil rights workers murdered by Klansmen in Philadelphia, Mississippi, in 1964—were well known. Others were not. Few around the country, for example, had heard of the remarkable bravery of Reverend George Lee, a Baptist minister in the Mississippi Delta town of Belzoni who began preaching about voting in the early 1950s. Lee formed a local chapter of the NAACP and worked to register African American voters in a county where there were no African Americans registered. He was warned to stop but refused. On May 7, 1955, while driving home, he was shot in the face and died. No one was ever charged.

The memorial consists of an upper and lower plaza. On the upper part, a sheet of water flows from a quotation that inspired Lin: "Until justice rolls down like waters and righteousness like a mighty stream." The lower plaza contains a twelve-foot-wide circular granite table with water emerging from the center and flowing in a thin sheet across its surface. Beneath the flowing water, inscriptions chronicling key moments in the history of the movement, including the deaths of the forty martyrs, radiate from the center like the hands of a clock. Lin wrote:

> *In choosing to intertwine events with people's deaths, I was trying to illustrate the cause-and-effect relationship between them. The struggle for civil rights in this country was a people's movement, and a walk around the table reveals how often the act of a single person—often enough, a single death—was followed by a new and better law. So many of the victims we don't know about, so many of the people we never heard about. What this movement was really about was the acts of an entire people. The Montgomery bus boycott is just one of many examples of this.*[24]

Lin left a blank space between the first and last entries of the Civil Rights Memorial's timeline to signify that the struggle for human rights began well before the first event listed in 1954 and that it continues to this day.

When the Civil Rights Memorial was dedicated, family members of the martyrs and others were moved by its power.

Among them was Mamie Till Mobley. Her son Emmett was just fourteen when he left Chicago to visit cousins in Mississippi in 1955. He was abducted after he supposedly whistled or said something disrespectful to a white woman, and his horribly disfigured body was found three days later floating in the Tallahatchie River. As was common at the time, the two white men charged with his murder—one of whom later admitted his guilt to a

magazine writer—were acquitted by an all-white jury. Mobley later wrote in *Death of Innocence: The Story of the Hate Crime That Changed America*:

> *I ran my fingers over the letters of Emmett's name and felt the cool water. I began to weep....It was like touching my son. Like reliving his funeral. But, as I told people there, it also filled me with such joy to see Emmett being honored, to see him included among the martyrs of the movement.*[25]

Caroline Goodman recalled the day her son's body was found buried in an earthen dam near the spot where he and two other young men were shot execution-style by Klansmen as they worked to register black voters during the Freedom Summer campaign in 1964. Their murders inspired the 1988 film *Mississippi Burning*. Goodman said:

> *When Andy's body was found, his father, now dead, said, "Our grief, though personal, belongs to our nation. This tragedy is not private. It is part of the public consciousness of our country." And this extraordinary monument has etched these losses in stone, and will be a lasting reminder of the courage and commitment to generations yet unborn.*[26]

The research conducted for the Civil Rights Memorial also helped revive decades-old civil rights cold cases. Few of the killers in those cases had been convicted. Some of the accused had been tried and acquitted by all-white juries even when the evidence of their guilt was overwhelming. Others had never been arrested. SPLC president Richard Cohen told Congress in 2007:

> *There simply was no justice for blacks during the civil rights era. The whole criminal justice system from the police, to the prosecutors, to the juries, and to the judges, was perverted by racial bigotry. Blacks were routinely beaten, bombed and shot with impunity. Sometimes, the killers picked their victims on a whim. Sometimes, they targeted them for their activism. In some cases, prominent white citizens were involved.*[27]

Inspired by the memorial, however, investigative journalist Jerry Mitchell used the SPLC book *Free at Last: A History of the Civil Rights Movement and Those Who Died in the Struggle* as a "road map on my journey into reinvestigating these cases,"[28] he recalled in 2005. Mitchell's investigations prompted prosecutions that put four Klansmen behind bars for some of the most heinous—and lethal—acts of the civil rights era, including the Sixteenth Street Baptist

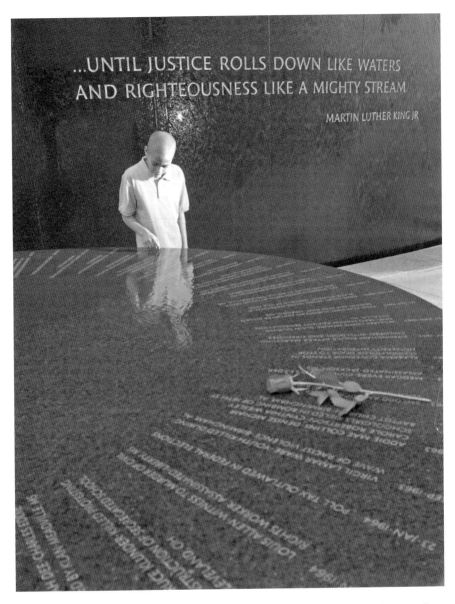

...UNTIL JUSTICE ROLLS DOWN LIKE WATERS
AND RIGHTEOUSNESS LIKE A MIGHTY STREAM

MARTIN LUTHER KING JR

Many people touch the names of those who gave their lives during the civil rights struggle. *Montgomery Convention and Visitors Bureau.*

Church bombing that killed the four little girls in Birmingham. Other killers were brought to justice as well.

"The Memorial," Mitchell explained, began as "a reminder that the martyrs' killers walked free, even though everyone knew they were guilty."

But "after it was dedicated in 1989, it transformed into an instrument of justice."[29]

As for the victims listed on the memorial, eight men were convicted for thirteen of the forty murders in the years following the 1989 dedication. Four others were convicted in another Mississippi killing.

Time and the lack of evidence have now closed the book on the remaining unsolved cases. But the Civil Rights Memorial stands as a perpetual reminder of the lives lost in pursuit of our nation's highest ideals. In his keynote speech at its dedication, the late civil rights icon Julian Bond spoke of the memorial's meaning:

> *Once, this cradle rocked with the violence of our opponents; today it is soothed by the waters of this monument which, like the movement it honors, is majestic in its simplicity, overwhelming in its power. It bears the names of 40 men, women and children who gave their lives for freedom. It recalls their individual sacrifice. And it summons us to continue their collective cause.*[30]

OLD ALABAMA TOWN

CAROLE KING

Old Alabama Town, the South's premier history village, is a collection of over fifty historic structures, some of which have been relocated to the six-block area of downtown Montgomery. Old Alabama Town is about people as well as buildings, and visitors have the opportunity to explore the historic structures and to learn about the people who built and occupied the buildings and the work they performed in an earlier time in Alabama. Old Alabama Town structures tell stories covering nearly one hundred years— from 1814 to the turn of the twentieth century. These stories tell about Alabama's frontier, its settlement and its development. Here, architecture is the instrument that depicts how people lived and worked in the nineteenth and early twentieth centuries. The stories in these buildings give people of today a unique connection to those of the past. In the Working Block, visitors can learn how people produced ordinary necessities, and in the Living Block, visitors can explore house museums where people gathered every day.

The Ordeman House was the first restoration of Landmarks Foundation, a nonprofit and Montgomery's leader in historic preservation, and remains the crown jewel of Old Alabama Town. The Italianate town house, on its original site, opened in 1971 and beautifully depicts upper-middle-class life in Montgomery in the 1850s. When Montgomery was the new capitol in 1846, the Ordeman House represented a new era in southern architectural tastes, inspired by the rampant romanticism of the era. While the town house retains a symmetrical form, the Italianate style introduced new design concepts, including the idea that columns were no longer essential to project

In 1970, Landmarks Foundation of Montgomery purchased a lot filled with old cars and transformed it into the Living Block of Old Alabama Town. *Landmarks Foundation.*

grandeur. The Ordeman House is an elegant brick structure, plastered and scored to look like stone. There are three stories, including a semi-basement surrounded by a moat. The floor plan is considered a half-house design, with the rooms on the south side and a hallway with a winding staircase along the north side. To maintain visual symmetry, the structure has false chimneys and windows, matching the actual ones on the south side. The architect, Charles Ordeman, limited exterior details to an iron-railed balcony on the southern and western façades, paired brackets lining the cornice and hood molds over the front windows.

The Ordeman House is surrounded in an aura of mystery involving failed aspirations, losses, disappearances, premarital agreements and low times. Charles Ordeman was a German immigrant who arrived in Montgomery to work as an architect and engineer in Montgomery's boom time of the 1850s. He lived in the cottage next door at 220 North Hull Street as the large house was being built. However, he never actually moved into the big house. He tried to sell it, but eventually, the house was sold in 1854 at public auction. The first actual occupants of the Ordeman House were Julius Caesar Bonaparte Mitchell and his wife, Rebecca, who were married in 1846. Their primary residence was a plantation in Mount Meigs, located in eastern Montgomery County. They moved into this house in town with

The Ordeman-Shaw House complex is on its original 1850s site and is complete with its original slave quarters, kitchen and other buildings. *Landmarks Foundation*.

their two children, Murdock and Posey, and by 1855, they had another daughter, Lilly. The family occupied the town house for four years while Julius continued to expand his planting operations in Mount Meigs. In later years, Mitchell became involved in the political activities that led up to the Civil War, attending the 1860 Democratic Convention in Charleston, South Carolina, with his friend statesman William Lowndes Yancey. During the Civil War, Julius organized the Thirty-Fourth Alabama Infantry and served for much of the war as its colonel. Rebecca, too, supported the cause, outfitting a battalion from Roanoke, Alabama, and actively participating in the Mount Meigs Ladies' Aid Society.

At the Ordeman House, an elegant, impressive collection of midnineteenth-century furniture, artwork, lighting devices, china and glassware shows the manner and style in which one element of society lived in antebellum Montgomery. Dominating the entrance hall is a gracefully curving staircase, and double parlors feature handsome, massive windows and door surrounds. The lady of the house would serve her guests in the stylish public front parlor, furnished in the fashionable Rococo Revival style; in the back parlor, with its handsome Empire motif design, the family would enjoy private time together in leisure activities of the day.

On the second floor, the master bedroom offers a bird's-eye view of the everyday activities happening below in the courtyard. The high half-tester bed was a popular furniture item that was actually manufactured in the Northeast and shipped to furniture stores in Mobile and New Orleans. The other bedrooms are furnished to depict the family's private life, including an early bathing room, a unique concept for the time.

On the lower level, a formal dining room catches the light from the setting sun in the west for the evening meal while the morning room has sunlight for many activities during the bustling daytime. A lower entrance made access to the working outbuildings much easier for transporting food from the warm kitchens.

The adjacent courtyard was the center of daily activities, such as cooking, cleaning, washing, gardening and other essential duties for everyday life in the city. The two-story brick structure served as kitchens on the first floor with slave quarters above; it is one of few surviving slave quarter structures of this type in Alabama. The thick brick walls with a fireplace in each room kept the structure warm in the winter. The many windows and doors and the balcony provided much-needed cross ventilation for cool breezes in the hot summers. On one side, the scullery was used for preparing food to be cooked—cutting, shucking, shelling, peeling and dishwashing. The cooking kitchen on the north side featured a wood stove and an enlarged hearth where the actual cooking of the food took place.

Julius Caesar Bonaparte Mitchell had slaves working on his plantation at Mount Meigs, so it is assumed he would have brought several with the family for use as house servants for domestic duties and groundskeepers for outside chores. These slave quarters are large enough for two families. Some of the domestic duties would include cooking, serving meals, house cleaning, washing and babysitting. The grounds keeping chores would entail yard work, gardening, carpentry, animal tending and carriage driving.

In the Living Block of Old Alabama Town, several house museums give visitors a view of life in central Alabama after the Civil War. The Yancey Dogtrot Cabin, located on East Jefferson Street, is an excellent example of a popular vernacular design that features two rooms joined by an open hallway. The dogtrot was well suited to Alabama's hot climate and became a fixture on the southern landscape. The breezes could move through the "trot," bringing welcome relief from the summer's heat. This two-room dogtrot stood on the plantation north of Montgomery on the Wetumpka Road and was purchased by Montgomery lawyer and ardent secessionist William Lowndes Yancey in 1859. Yancey was a journalist, politician, orator

The Ordeman-Shaw House slave quarters are two rooms located over the kitchen and scullery. *Landmarks Foundation.*

and diplomat and an American leader of the southern secession movement. A member of the group known as the Fire-Eaters, Yancey was one of the most effective agitators for secession and defenders of slavery. During the 1850s, Yancey could hold large audiences under his spell for hours at a time with his passionate speeches, and at the 1860 Democratic National Convention, Yancey was instrumental in splitting the party into northern and southern factions. When the newly established Confederate States of America met in February 1861 in Montgomery to establish their formal union, Yancey delivered a welcome speech introducing Jefferson Davis, the newly selected provisional president, on his arrival at Montgomery. Yancey accepted Davis as a good choice to lead the Confederacy, introducing him with the well-known words: "The man and the hour have met. We now hope that prosperity, honor, and victory await his administration."[31] During the Civil War, Yancey was sent by President Davis as a diplomat to Europe to secure formal recognition for the new Confederate States of America. He returned to Alabama in 1862 and was elected to the Confederate States Senate, where he became critical of the Davis administration. Suffering

from ill health for much of his life, Yancey died of kidney disease in this house in July 1863 at the age of forty-eight.

The shotgun, a significant structure in the history of southern vernacular architecture, answered the need for economical housing, particularly in urban areas like Montgomery in the late nineteenth century. The Old Alabama Town shotgun was moved in 1977 from its original location on Bainbridge Street, not far from the capitol. Anthropologists and archaeologists believe that the shotgun house form evolved from a Nigerian house style brought to Haiti by slaves. After the Haitian revolution at the end of the eighteenth century, thousands of refugees descended on coastal southern cities, bringing their architectural knowledge, and introduced the house form to the southern United States. The smaller houses proved ideal for space-saving investment properties in urban areas, fitting on long, narrow street-front lots. With the front and back doors lining up in the gable ends, the structure could also be easily added on to, with room after room extending in the rear.

The exodus of former slaves from plantations into towns after the Civil War created a serious housing problem. Shotguns offered a sensible, economic solution, and soon block after block of these little homes appeared in Montgomery and other urban areas. Here in Montgomery, Moses Brothers Banking and Realty Company constructed many shotguns, and when the firm went bankrupt in the early 1890s, its holdings, including the house in Old Alabama Town, were sold. Willis Willingham purchased two shotguns on Bainbridge Street; he occupied one himself and rented the other to Grant and Vinie Fitzpatrick. Grant worked on the railroad, and his wife, Vinie, took in laundry. The newspaper on the wall acted as insulation by keeping out the drafts. The furniture and room arrangements illustrate how many late nineteenth-century urban dwellers had little or no privacy. Black Culture Preservation Committee assisted in the restoration of the house and contributed many of the items from personal family collections.

Also, in the Living Block, the Old Alabama Town church depicts the African American Presbyterian worship tradition. In antebellum Alabama, for the majority of religious services, whites and blacks worshipped together, with the latter sitting in a separate gallery reserved for them. By the 1880s, the African American members of Montgomery's First Presbyterian Church requested a separate congregation, which triggered the construction of this church at the corner of Stone Street and Cleveland Avenue. For several years, the white church monitored the congregation's activities, such as overseeing the hiring of black ministers to preach. In 1888, at the request of the new congregation, the regional Presbyterian session voted to "dismiss from this

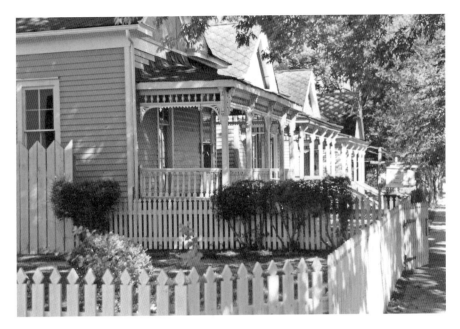

Historic homes that now serve as offices on North Hull are part of Old Alabama Town. *Landmarks Foundation.*

church the colored members that they might organize a church of their own officers and under the name of the 'First Presbyterian Colored Church of Montgomery.'"[32] The new congregation of African Americans continued to worship together, supporting their own place of worship, and remained active until the late 1960s, when threats of interstate construction forced the congregation to relocate. The church was moved to Old Alabama Town, restored and dedicated in 1977. The simple one-room structure has notable architectural features, including long, large windows shielded by louvered shutters and handsome cornice moldings. The interior consists of horizontal board paneling with accent wainscoting. Today, the church continues to play a vital role within Old Alabama Town, symbolic of the religious traditions of this region.

These buildings are just a few of the historic house museums that contributed to Montgomery's rich civil heritage tradition spanning two centuries. Old Alabama Town tickets are available at the Loeb Reception Center at 301 Columbus Street, adjacent to Kiwanis Park. For more information on the variety of educational tours and experiences available, go to www.landmarksfoundation.com or call 334-240-4500.

ST. JOHN'S EPISCOPAL CHURCH

MATTIE PEGUES WOOD AND ROBIN NORRED

S t. John's Episcopal Church is both a historic place of worship and a moving aesthetic experience. The radiant, stained-glass windows and the arches reaching to the vaulted ceiling contrast with the church's original appearance. The plain, modest structure completed in December 1837 in no way resembled the present cathedral-like building. When St. John's was first established, Alabama was officially only fifteen years old. St. John's Episcopal Church was the first brick church in town and was just large enough to accommodate forty-eight pews. After years of no formal church building of any kind, this solid, but simple, little church was a great luxury. Almost simultaneously, St. John's Episcopal Church and four other churches of various denominations sprang up to serve a community of only a few thousand souls.

Early Episcopalians here and elsewhere were vastly outnumbered by other denominations; the community was a remnant of the British Anglican Church, cut off from its mother church after the Revolutionary War. This remnant was often harassed nearly out of existence by fellow colonists, who suspected them of Tory leanings despite the fact that their ranks had included such undeniably loyal Americans as George Washington, Patrick Henry, Alexander Hamilton, Francis Scott Key, Presidents Madison and Monroe and hundreds of other Patriots. Nevertheless, the little brick church boldly set forth on its mission. Soon the pews were sold to individuals and families, who, in turn, were handed legal titles to occupy the pews, which

they passed on to their heirs. This practice allowed the church to cover its expenses, such as the $800 annual salary of the first rector, the tempestuous Reverend Mr. William Johnson from South Carolina.

The fledgling church was located in an opportune spot. In 1846, Montgomery became the capital of the state. It was also the key inland shipping center of a region that produced more cotton than any other place of comparable size. Log cabins became gracious mansions. Steamboats passed on their way to and from Mobile carrying bales of cotton, mail, news of the world, the best fabrics and the latest fashions from Paris.

In 1845, St. John's Episcopal Church acquired a prodigious bell. It was made by Messts, Allain, & Co. of New York; weighed 1,045 pounds; and cost $376.16. Hoisted onto a frame in the churchyard, it summoned communicants to worship for the next forty years.

St. John's Episcopal Church's congregation grew with the town. By 1853, with its third rector, Mr. J.H. Morrison, in the pulpit, the congregation had increased to 110 members. Clearly, more room was needed. So, in 1855, a new and larger church was completed that remains the heart and core of the building that has been passed down to the community today. The new structure of 1855 consisted of what is the narthex (an entrance hall at the west end of a Christian church between the porch and the nave) and nave (the main body of the church) of the present church and the roof and tower above them.

To design the building, its planners had called on the nation's foremost church architects, Wills and Dudley of New York. Frank Wills believed that no Christian church was all it should be if its basic structure did not symbolize the joyous triumph of the Ascension and the belief in an afterlife. From this conviction came the clean loftiness of St. John's Episcopal Church's steeple and the grand upsweep of its roof. The 1855 part of the building is said to be a replica of an ancient church in Coventry, England, that was destroyed later by German bombers in World War II.

Many African Americans had become Episcopalians. They were given the use of the old brick church and began conducting their own services there. Thus, there was no need for a slave gallery in the new St. John's; instead, its loft was designed to accommodate the choir and the organ.

Prior to 1858, St. John's Episcopal Church became known as the "Cathedral Church" because its fourth rector was also the first bishop of the Diocese of Alabama, the Right Reverend Nicholas Hamner Cobbs. Moving here from Tuscaloosa, he brought with him the prestige and power of the great humanitarian bishop he was. Being a shy, quiet man did not hinder

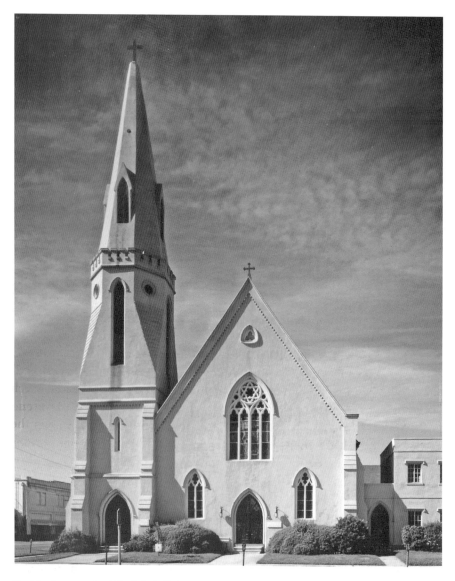

In this photograph of St. John's Episcopal Church, the front is easy to see because the trees are not yet large. *Landmarks Foundation.*

the zeal he exhibited for starting new churches in remote areas of Alabama, such as Wetumpka, Robinson Springs, Mount Meigs and Hayneville—places that were still largely untouched wilderness at the time. His efforts were responsible for the building of eighteen new Episcopal churches in Alabama between 1850 and 1860.

It was a prosperous decade. Traveling theater companies and operas enriched the town's life, as did elaborate dances of the time. In the midst of this prosperity, Montgomery was the first town in Alabama lighted by gas in 1854, just in time to light candles in the tall brass standards for the consecration the following year of the new St. John's Episcopal Church.

As time passed, the nation's controversy over slavery—and other issues—grew steadily louder and more strident. Bishop Cobbs warned secession would lead to war. Having become very ill as 1860 ended, he prayed that he would not live to see the inevitable war. His wish was granted when he died at his home on January 11, 1861, just minutes before the booming guns on the capitol grounds ten blocks away announced the news of Alabama's secession from the Union.

For four months, Montgomery was the exhilarated, thronging capital of the new Confederate States of America. During this time, President Jefferson Davis and his wife and family attended Sunday services at St. John's Episcopal Church regularly. Earlier, Davis had penned to his wife, Varina, before she joined him: "This is a gay and handsome town of 8,000 inhabitants."[33]

In July 1861, St. John's Episcopal Church was the host of the historic Secession Convention of the Southern Churches. Here, it joined with all the others in voting to establish the Protestant Episcopal Church in the Confederate States of America. St. John's rector, the Reverend John March Mitchell, son-in-law of the late Bishop Cobbs, assumed the powerful post of secretary of the organization and held that position for the duration of the war.

In April 1862, a Confederate regiment recruited largely from Montgomery was practically wiped out at the Battle of Shiloh. Full realization of the horror of war came home with the list of the dead. Many children were orphaned, and St. John's Episcopal Church's response was to take them into the newly created Bishop Cobbs orphanage run by the church women, some of whom also volunteered to serve as teachers. Throughout the war, the women of St. John's gathered nearly every day to sew, making shirts, uniforms and bandages for men away at the front lines. When there were no blankets to send the soldiers, they helped cut up the plush carpets at the state capitol to serve as blankets.

Despite the waning hopes of the Confederacy at the dawn of 1864, the spirit of the women sewing at the church remained unbroken. They learned to make dyes from native plants, lemonade from maypops, ink from rusty nails and mucilage for sealing envelopes from peach tree gum.

April 12, 1864, saw the arrival of Union troops known as Wilson's Raiders in Montgomery. Their arrival usually meant the total destruction of a town. Although five steamboats, two mills, an arms factory, two stores of ammunition, a nitre works and all the rolling stock of the railways were burned, most of the churches and homes were spared. In September 1865, all the Episcopal churches in Alabama were closed by order of the Union army. St. John's communicants worshiped in private homes until 1866, when civil authority finally replaced the military and the restrictions were removed. Also in that year, the bishop called a diocesan council meeting at St. John's Episcopal Church, where the decision was made for the Diocese of Alabama to return to the national church.

After the war, the South's economy was ruined. Its soldiers drifted home, crippled, hungry and despondent. Many families, wealthy before the war, found themselves impoverished, their property confiscated by the federal government and sold to strangers. During this time, a remarkable event took place. In 1869, just four years after the war's end, St. John's Episcopal Church's parishioners somehow managed to enlarge the church in significant and costly ways. To rein in the cost, the original church was leveled, and its bricks were used to lengthen the new church, creating the section that is now the chancel and sanctuary. At the time, the choir stalls and organ were moved to the chancel, and the loft became a gallery for the freed African American communicants who still wished to come there and worship. Other savings were made possible by the energy, enthusiasm and talents of the new rector, Dr. Horace Stringfellow. He personally did much of the finer remodeling work and inspired an all-out effort on the part of others. Many beautiful details here today are the heritage of his twenty-five-year incumbency. Until 1869, the ceiling of the church was bare plaster. It was Dr. Stringfellow's idea to mellow it with a wooden lining. He suggested the designs of the richly hued symbolic medallions and climbed the scaffold to help paint them on the ceiling.

In 1885, the old church bell rang for the last time and was replaced by a carillon in the tower. Also that year, there was another new sound in Montgomery—that of the town's first electric streetcar clanging up Court Street. The St. John's Episcopal Church community continued to match the pace of the growing community around them.

In 1897, an epidemic of yellow fever reached such proportions that public meetings were forbidden, and the church closed its doors. The seventh rector, Reverend Dudley Powers, fled out of range of contamination, as did many

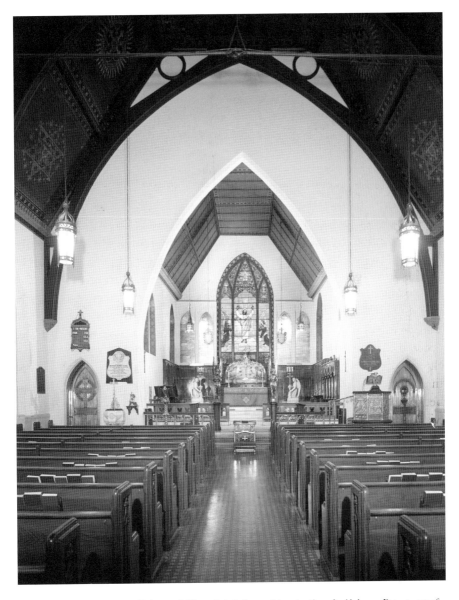

The interior of St. John's Episcopal Church is lofty and inspirational. *Alabama Department of Archives and History.*

others. Those who did not leave risked their lives by remaining in town to nurse the sick and dying.

St. John's Episcopal Church's eighth rector, though ill, was a dynamic educator and social reformer. He founded (in 1890) the Church of the

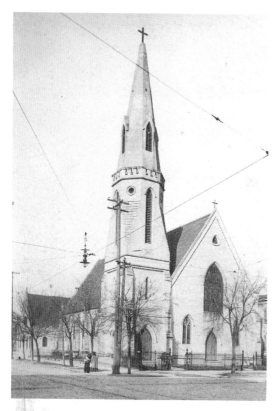

The antebellum St. John's Episcopal Church was designed by Wills and Dudley of New York. This circa 1907 photograph shows the modern era's intruding power lines, poles and streetlights. *Landmarks Foundation.*

Good Shepherd to provide St. John's African American communicants with a church of their own and was active in passing better child labor laws. His brilliance and charm won him powerful allies who helped secure the money for the building of the Montgomery Public Library and the funds to purchase adequate quarters for the local YMCA. Upon his retirement, Edward Ellerbe Cobbs, grandson of Alabama's first bishop, stepped into the role as the youngest, then twenty-five years old, rector in the South.

In 1906, the church was again enlarged in the north and expanded on each side in an easterly and westerly direction. New doors were cut through on the old walls on each side. Italian mosaic tile was laid on the floor of the enlarged chancel. Families who had purchased or inherited their own private pews continued to sit in them whenever possible. But with both new members and visitors increasing, they found it awkward and inhospitable to adhere rigidly to this custom. They quietly relinquished their titles to ownership of the pews, and a sign appeared near the main entrance: "All Pews Are Free. Strangers Are Welcome."

In November 1917, St. John's Episcopal Church acquired its gem of a chapel, a beautiful and complete little church within a church. It was a gift of Alice Hereford Farley in memory of her husband, John Gallegher Farley.

During World Wars I and II, the congregation did its part. Many men enlisted in the services and many women signed on as nurses, Gray

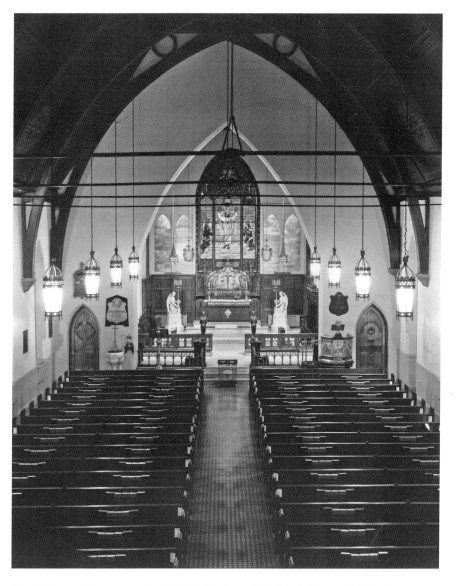

The Tiffany window is seen in this interior shot of St. John's Episcopal Church. *Landmarks Foundation*.

Ladies and members of the canteen and the Surgical Dressing Corps. As a congregation, they gathered for prayer when the news spread that "the Invasion has begun!" on D-day, June 6, 1944.

Upon the arrival of Reverend Charles H. Douglas on June 1, 1957, radical change was taking place in Montgomery. The city was aflame

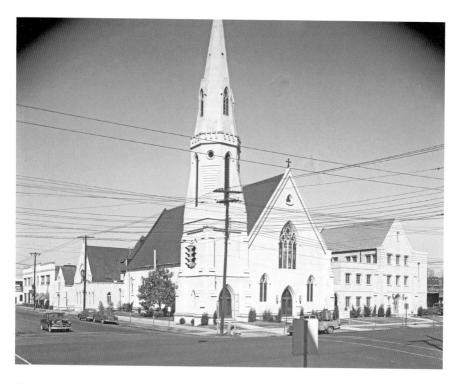

Above: St. John's Episcopal Church in 1952 had power lines close by and traffic from Madison Avenue. *Alabama Department of Archives and History.*

Left: The steeple of St. John's Episcopal Church is a longtime landmark along Madison Avenue. *Alabama Department of Archives and History.*

over abrupt social changes brought on by the civil rights movement. Several churches brought disruptive and dangerous incidents on themselves by responding hostilely to African Americans who attempted to attend their services. The common sense and sound moral code of Douglas steered St. John's Episcopal Church clear of such pitfalls. "Never question anyone's motives for coming to church," he advised his parishioners. "Anybody who wants to come to St. John's—let him come and welcome, as long as he behaves himself. Why he comes is his business, not ours."[34]

In modern decades, old St. John's has not allowed itself to forget that one of its main reasons for being is still mission work. Accordingly, under the continuous strong leadership of the rector, the church has made generous financial contributions to help newer parishes become established, and succeed, in the fast-expanding eastern sections of town. Such generosity has required some real sacrifices on the part of St. John's. One of the greatest of these is that it loses a percentage of its members to new and more conveniently located Episcopal churches in the suburbs.

Nevertheless, despite all drains on it, including the mass exodus of the city's population from urban to suburban areas, the old church on Madison

A current view of St John's Episcopal Church shows full-grown trees and traffic lights. *Landmarks Foundation.*

Avenue has more than held its own. The current communicants constitute a mature, unshakable and unswervingly loyal corps, many of them tied to the church by history as well as emotion. This is where they want to be and where they will remain.

APPENDIX

CIVIL WAR IN MONTGOMERY TIMELINE

Contributed by Jeff Benton

January 7, 1861	Secession Convention
January 11, 1861	Delegates vote to secede
February 4, 1861	Montgomery becomes provisional capital of the Confederacy
February 18, 1861	Jefferson Davis inaugurated president of the Confederacy
March 4, 1861	First national Confederate flag raised over Alabama capitol
March 11, 1861	Confederate Congress adopts permanent constitution
April 11, 1861	Telegram sent to fire on Fort Sumter
May 21, 1861	Confederate capital moved to Richmond
April 11, 1865	Confederate soldiers torch downtown warehouses to destroy cotton rather than let it fall into enemy hands
April 12, 1865	Mayor W.L. Coleman and city council surrender Montgomery to General Edward McCook. General McCook acted as a part of Major General James Harrison Wilson's troops, known as "Wilson's Raiders."

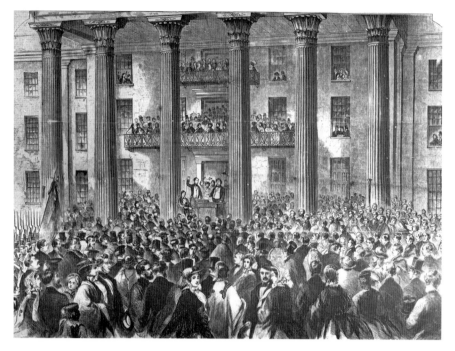

Frank Leslie's Illustrated Newspaper covered the inauguration of Jefferson Davis, president of the Southern Confederacy. *Alabama Department of Archives and History.*

MONTGOMERY'S ROLE IN THE MODERN CIVIL RIGHTS MOVEMENT

Contributed by Jeff Benton

Montgomery played a leading role in the modern civil rights movement (1955–65):

- Montgomery Bus Boycott of 1955–56
- Churches and ministers' homes bombed by the Ku Klux Klan in January 1957
- Alabama State University student sit-in and boycott/KKK crisis of February–March 1960
- Freedom Riders riots and fire bombings of May 1961
- Mounted posse–KKK attacks of February–March 1965
- Selma–Montgomery Voting Rights March of 1965

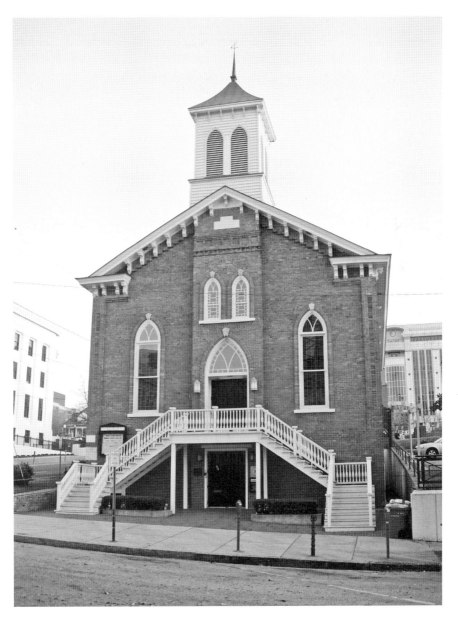

The community at Dexter Avenue King Memorial Baptist Church was active in the Montgomery Bus Boycott and later civil rights movement events. *Landmarks Foundation.*

CIVIL RIGHTS TIMELINE

Contributed by Jeff Benton

1800–66	Slave states' Black Codes restrict slaves' civil rights and liberties.
1864	Thirteenth Amendment abolishes slavery.
April 1865–December 1865	Presidential Reconstruction begins, and Union army is demobilized.
1866	Radical Republican Congress passed (but states ratify later) the Civil Rights Act of 1866, giving freedmen the right to sue, serve on juries, etc. The South resists with KKK actions, race riots and vigilante violence.
1867	Radical, congressional military Reconstruction continues: • Fifteenth Amendment: freedmen have right to vote • South institutes Black Codes • federal government responds by giving U.S. Army power to protect African Americans
1868	Congress readmits Alabama to the Union. Fourteenth Amendment makes freed slaves U.S. citizens.
1872	Liberal Republicans are elected and work to end Reconstruction.
1873	Hayes withdraws U.S. troops; radical Republican state governments collapse.
1874	Reconstruction ends in Alabama.
1877–1954	Jim Crow laws: The term "Jim Crow" originates from a folk song that presented African Americans as a negative stereotype. By 1838, "Jim Crow" had come to be a derogatory term for African Americans. During Reconstruction, there were concerted efforts by whites to negate civil rights gained by freedmen. Several national equality laws were enacted but to no avail, including the Civil Rights Act of 1875 (ruled unconstitutional by Supreme Court in 1883). Montgomery freedmen tested this law in the Montgomery Theater. It was one of the country's first examples of African Americans attempting to assert their newly granted federal civil rights; it failed.

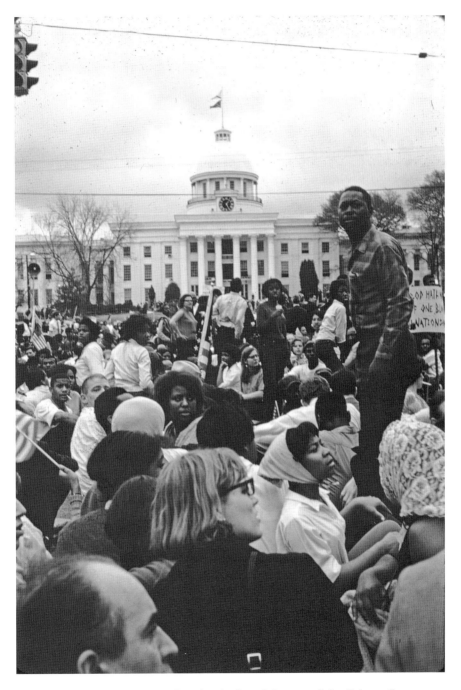

Selma–Montgomery marchers gathered at the foot of the steps of the Alabama State Capitol on March 25, 1965. *Alabama Department of Archives and History.*

1887	Separate but equal concept is adopted, challenged in federal courts and ruled valid by Supreme Court (*Plessy v. Ferguson* in 1896); de jure (by state and local law) segregation in South continues; de facto (customary) segregation in the South and elsewhere in the United States continues with racial housing segregation—not by law, but by private covenants, mortgage lending practices and other racial hiring practices—and job and union discrimination.
1901	Reactionary Alabama Constitution disenfranchises black men and tens of thousands of poor white men through poll taxes, literacy and comprehension tests, residency requirements and grandfather clauses.
1906	An African American boycott of Montgomery's streetcar system is held when the city mandated racial segregation of the streetcars. Throughout the South, and in the national armed forces, strict racial segregation is maintained. Institutions like churches (with slaves in the back or in balconies) that had been integrated to an extent are racially separated. Housing, job categories, union membership, schools and public accommodations (medical treatment, transportation, restaurants, hotels, public restrooms, water fountains, etc.) are divided by race. These racial segregation practices are also observed in areas outside the South.
1947	Truman, by executive order, integrates the U.S. armed forces
1954	*Brown v. Board of Education* begins modern civil rights movement. In general, the South refuses to conform for a decade.

TIPS FOR THE CIVIL HERITAGE TRAIL

1. Use the map from the brochure or the book, but you do not have to visit every site in order.
2. Be realistic about how many sites you can walk to in the time you have. If you become tired, there are cafés on some blocks.
3. Some sites are most probably not comfortable to walk to, such as Old Alabama Town and even St. John's Episcopal Church. However, do plan to visit those sites by vehicle, as they are beautiful, inspirational and enjoyable.

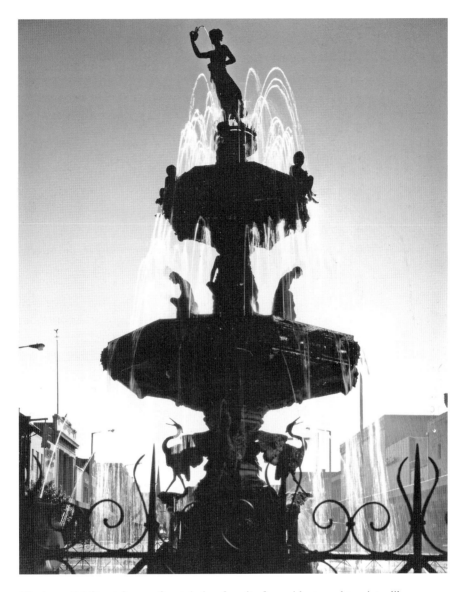

The beautiful Court Square fountain is a favorite for residents and tourists alike. *Landmarks Foundation.*

4. Wear comfortable shoes. You will be walking a cityscape, but dress shoes can become uncomfortable pretty quickly.
5. Notice that the city and, therefore, the tour is not laid out chronologically. As you go along, you will be jumping back and forth between Civil War and modern civil rights movement sites.

6. Be aware you are walking in a city and be mindful of traffic and traffic lights.
7. There are other signs that explain the sites and signs that point out locations and information not on the trail. Take time to enjoy the whole experience.
8. In addition to locations on the trail, many of the sites offer extensive exhibits that deepen your understanding of the Civil War and the civil rights movement but require some time. Some to consider are the Civil Rights Memorial Center, the Rosa L. Parks Museum, the Freedom Rides Museum, the Dexter Avenue King Memorial Church tour, the First White House of the Confederacy interior, the Museum of Alabama at the Alabama Department of Archives and History and the Old Alabama Town tour.

NOTES

1. Goodheart, "Disunion."
2. Williams, *Eyes on the Prize*, 66.
3. Lewis, *Compilation of the Messages and Speeches of Theodore Roosevelt*, 716.
4. Taylor and Neeley, *Way It Was*, 111.
5. Ibid.
6. Ibid.
7. *New York Times*, "Honoring Freedom Riders."
8. Lewis, *King*, 133.
9. Handy, "Welcome!" *Dexter Avenue King Memorial Baptist Church*.
10. Evans, Gary and Alexander, *Dexter Avenue Baptist Church Collection*, 10.
11. Ibid.
12. Ibid.
13. Handy, "Welcome!" *Dexter Avenue King Memorial Baptist Church*.
14. Benton, *Sense of Place*, 53.
15. Williamson, "Monuments and Markers."
16. Ibid.
17. Napier, *First White House of the Confederacy*, 4.
18. Ibid.
19. "Southern Poverty Law Center Collections: Dedication Ceremony Select Transcripts."
20. Brooks, "Civil Rights Memorial Celebrates 25th Anniversary."
21. Lin, *Boundaries*, 4:26.
22. Ibid., 4:27.

23. Dees, "Memorial Honors the Victims of Racial Violence."
24. Lin, *Boundaries*, 4:28–29.
25. Mobley and Benson, *Death of Innocence*, 258.
26. "Southern Poverty Law Center Collections: Dedication Ceremony Select Transcripts."
27. Cohen, "Testimony of Richard Cohen Before the Subcommittees on Crime, Terrorism, and Homeland Security."
28. "Southern Poverty Law Center Collections: Dedication Ceremony Select Transcripts."
29. Ibid.
30. Ibid.
31. Walther, *William Lowndes Yancey*, 295.
32. Neeley, *Old Alabama Town*, 46.
33. Wood, *Life of St. John's Parish*, 15
34. Ibid., 18.

BIBLIOGRAPHY

Benton, Jeffrey C. *A Sense of Place: Montgomery's Architectural Heritage 1821–1951*. Montgomery, AL: River City Publishing, 2001, 53.

Brooks, Lecia. "Civil Rights Memorial Celebrates 25th Anniversary." Southern Poverty Law Center. www.splcenter.org/new/2014/11/05/civil-rights-memorial-25th-anniversary-o.

Cohen, Richard. "Testimony of Richard Cohen Before the Subcomittees on Crime, Terrorism, and Homeland Security and on the Constitution, Civil Rights, and Civil Liberties." Committee on the Judiciary U.S. House of Representatives. June 12, 2007. www.splcenter.org/news/2015/07/27/testimony-richard-cohen.

Dees, Morris. "Memorial Honors the Victims of Racial Violence." Interview by Ronald Smothers. *New York Times*, November 4, 1989. www.nytimes.com/1989/11/4/us/memorial-honors-the-victims-of-racial-violence-html.

Evans, Zelia S., ed., Virginia Gary with J.T. Alexander. *Dexter Avenue King Memorial Baptist Church Collection*. Montgomery, AL: Dexter Avenue Baptist Church, 1979.

Goodheart, Adam. "Disunion." *Opinionater*, January 28, 2011. www.opinionator.blogs.nytimes.com.

Handy, Cromwell A. "Welcome!" *Dexter Avenue King Memorial Baptist Church*. www.dexterkingmemorial.org.

Lewis, Alfred Henry, ed. *A Compilation of the Messages and Speeches of Theodore Roosevelt*. Vol. 1. New York: Bureau of National Literature and Art, 1906, 716.

Lewis, David Levering. *King: A Biography*. 3rd ed. Chicago: University of Illinois Press, 2013, 133.

Lin, Maya. *Boundaries*. New York: Simon and Schuster, 2000, 26–29.

Mobley, Mamie Till, and Christopher Benson. *Death of Innocence: The Story of the Hate Crime That Changed America*. New York: Random House, 2004, 258.

Napier, Cameron Freeman. *The First White House of the Confederacy*. Montgomery, AL: First White House Association of Alabama, 2009, 4.

Neeley, Mary Ann. *Old Alabama Town*. Tuscaloosa: University of Alabama Press, 2002, 46.

New York Times. "Honoring Freedom Riders at an Old Bus Station." May 22, 2011. www.nytimes.com/2011/05/22/us/22freedom.html.

"Southern Poverty Law Center Collections: Dedication Ceremony Select Transcripts." Southern Poverty Law Center Collection. Montgomery, AL, 2004.

Taylor, Beth, and Mary Ann Neeley. *The Way It Was: Photographs of Montgomery and Her Central Alabama Neighbors*. Montgomery, AL: Landmarks Foundation of Montgomery, 1985, 111.

Walther, Erich H. *William Lowndes Yancey: The Coming of the Civil War*. Chapel Hill: University of North Carolina Press, 2006, 295.

Williams, Juan. *Eyes on the Prize: American Civil Rights Years*. New York: Penguin Books, 2010, 66.

Williamson, Roger. "Monuments and Markers: Alabama State Capitol Building and Grounds." Montgomery: Alabama Historical Commission Internal Document, 1997.

Wood, Mattie Pegues. *The Life of St. John's Parish*. Montgomery, AL: St. John's Episcopal Church, 1955, 18.

ABOUT THE AUTHORS

James T. Alexander served in World War I and worked as a county agricultural extension agent for thirty-one years. He was active in civic affairs and influential in voter registration. He served as a deacon and was a chairman of the board of deacons for the Dexter Avenue King Memorial Baptist Church.

Felicia A. Bell, PhD, received her bachelor's degree in history from Savannah State University, her master's degree in historic preservation from Savannah College of Art and Design and her doctorate in U.S. history from Howard University. In 2007, she gave testimony before the U.S. House of Representative's Committee on House Administration about the use of enslaved and free black craftsmen who worked to construct the U.S. Capitol. Her testimony, along with others, resulted in a bill to name the Capitol Visitor Center's great hall "Emancipation Hall." Dr. Bell was appointed director of the Rosa Parks Museum in 2015.

Jeff Benton holds an undergraduate degree from the Citadel and graduate degrees from the University of North Carolina–Chapel Hill, Auburn University and Auburn University–Montgomery. He retired from the air force as a colonel after twenty-six years of service. His books and lectures on Montgomery and Alabama are as important as they are enjoyable.

Ralph J. Bryson, PhD, earned his doctorate in English and education from Ohio State University. He worked as a professor and department chair at Alabama State University until his retirement. Dr. Bryson is a writer and a historian and active in the church community of Dexter Avenue King Memorial Baptist Church.

Eleanor Williams Cunningham holds a bachelor of arts in anthropology from the University of Georgia and a master of arts in anthropology from Eastern New Mexico University, both with a focus on archaeology. Since 1999, she has worked for the Alabama Historical Commission; she currently serves as the director of the Historic Sites Division. Eleanor loves helping others make a connection to the past through visiting historic sites and enjoys the little-known and often quirky side notes of history.

Jeff Dean holds a bachelor of arts from Harvard University. He currently works as director of Greystone Real Estate Advisors based in New York City. Jeff Dean says that working in real estate development taught him that "a place is not simply a geographic location but also the assumptions and beliefs that people bring to that location."

Morris Dees, an Alabama native, is the founder and chief trial counsel of the Southern Poverty Law Center. His landmark civil rights lawsuits helped demolish remnants of Jim Crow segregation in the Deep South and destroyed some of America's most notorious white supremacist groups. He is the recipient of numerous awards, including the Martin Luther King Jr. Nonviolent Peace Prize bestowed by the King Center.

Zelia Stephens Evans graduated from Alabama State University and received her master of arts and EdD in education from the University of Michigan. She taught for twenty-two years as a professor of education and served as director of the Early Childhood Center at Alabama State University, which now bears her name: the Zelia Stephens Early Childhood Center.

Virginia Gary graduated from Alabama State University and earned her master's in education at the University of Minnesota. She worked as a teacher and librarian in the Montgomery Public School system for over thirty years. She served as one of the first female deacons for Dexter Avenue King Memorial Baptist Church. During that time, she wrote extensively on the church's history.

Booth Gunter is a senior editor at the Southern Poverty Law Center. He is an award-winning journalist covering politics, criminal justice and the environment.

Georgia Ann Conner Hudson holds a bachelor of arts in both history and studio art from Furman University in Greenville, South Carolina. Since 2013, she has been the communications officer at the Alabama Department of Archives and History. Georgia Ann Hudson is a board member of Montgomery's Downtown Business Association and serves on the Civil Heritage Trail Committee.

Carole King earned a bachelor's degree in interior furnishing from Auburn University and then studied historic preservation, museum studies and folklore at Western Kentucky University for a master's degree. She has been the historic properties curator for Landmarks Foundation, managing the collection at Old Alabama Town for over thirty-four years. Carole King has coauthored several books on Montgomery history and a running set of articles on historic Montgomery properties for the *Montgomery Advertiser*.

Cameron Freeman Napier graduated from the University of Alabama. Cameron served as regent for the White House Association of Alabama for twenty-nine years, until 2009. She is, therefore, the past regent and honorary regent for life of the White House Association of Alabama.

Mary Ann Neeley has a bachelor of arts degree in education from Huntingdon College and a master's degree in history from Auburn University. She was executive director of Landmarks Foundation—Montgomery's preservation organization—for twenty-five years. As director, Mary Ann was instrumental in the expansion and development of Old Alabama Town with its premier collection of historic museums. Now as director emeritus, Mary Ann has several well-known books to her credit and remains active in preserving Montgomery's architectural history.

Robin Norred has a master of science in elementary education and has worked as a sixth grade language arts teacher for twenty-six years. She taught U.S. history for several years and, during that time, learned to appreciate "the valuable lessons embedded in historical events."

Ken Reynolds received a bachelor of science from Samford University and also graduated from Jones School of Law. He has worked for seven

years as the event planner for the Special Events Department of the City of Montgomery.

Anne Henry Tidmore is a graduate of Huntingdon College. She has served as regent of the White House Association of Alabama since 2009.

Dorothy Walker has a master of arts in historic preservation from Savannah College of Art and Design. She has over eighteen years of experience working in historic preservation and cultural resource advocacy. Dorothy Walker spent two and a half years at Alabama State University's National Center for the Study of Civil Rights and African American Culture as the cultural heritage manager. Since 2015, Dorothy Walker has served as the first full-time site director for the Freedom Rides Museum, located in the historic Greyhound bus station, and is coordinator for the Black Heritage Council.

Mattie Pegues Wood graduated from Mississippi State College for Women. She then attended classes at Columbia and Harvard. She taught school up to the time she married George Wood. She wrote *The Life of St. John's Parish* to mark St. John's Episcopal Church's centennial in 1955.